a manual for drawing and painting

Elizabeth Andrewes was trained in graphics at the Central School of Art and Design and practised as a designer, illustrator and typographer; she was made a Member of the Society of Industrial Artists and Designers before becoming an instructor at the Berkshire College of Art and Design. For ten years she has been teaching drawing and painting to students of all ages and from all walks of life.

D1079752

TEACH YOURSELF BOOKS

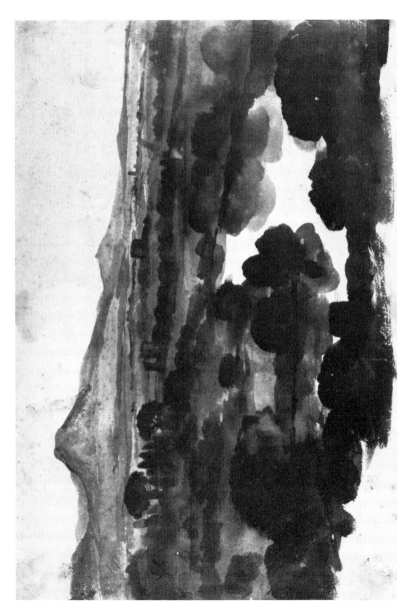

a manual for

drawing & painting

Elizabeth Andrewes

TEACH YOURSELF BOOKS

Hodder and Stoughton

a manual for drawing and painting

first printed 1978
copyright © 1978 Elizabeth Andrewes
fourth impression 1986

ISBN 0 340 22243 3

printed in Great Britain for Hodder and Stoughton Educational, a division of Hodder and Stoughton Ltd, Mill Road, Dunton Green, Sevenoaks, Kent, by Hazell Watson & Viney Ltd, Aylesbury, Bucks

contents

introduction *how to use this book*

Learning is fun and not a duty if you remember that all rules are made to be broken, as well as kept; rules are no more and no less than the beginner's life-line. This is not just a book of rules but a record of the help and information that most mature students need when learning to draw and paint, and it is put together not for armchair reading but in the form of a manual, to make reference easy and a logical course of study possible for those who may have only limited time and funds available. Art-jargon is always daunting if not incomprehensible to the layman; technical terms have been defined to make their meaning straightforward and easily accessible. The usual foundation course, followed by first-year art-students, would hold little attraction for the mature student starting out, except as artistic medicine. It is only after experience of the design problems involved in the various aspects of drawing and painting that the need for specific study and exploration outside traditional paths becomes apparent.

The aim of section one, *different materials and suitable subjects*, is to provide this general experience as quickly as possible through the use of different mediums, assisting the individual to discover, appreciate and direct his own talent. This is often difficult, for many would like to aim at a style of painting based on a lengthy academic training, often of another era. To know more of the history of painting—its movements and achievements—does help each student to assess what is relevant to him, and to gain satisfaction from the appropriate choice and use of materials. Section two, *elements and techniques of picture-making*, examines in more detailed fashion the ground covered in the first section. Section three, *relevance of design and its application*, is headed by what could be described as a two-dimensional design vocabulary, the necessary basis for more advanced study and for the succeeding chapters on flower-painting, figure-drawing, portraiture and lettering. It relates the abstract ingredients of painting to everyday life.

The total beginner, starting with fewer preconceived ideas, may well have an advantage over someone who has studied a little at various times but whose knowledge may be unexpectedly patchy. Even if the area covered by a particular chapter is familiar territory, it is still a good plan to work consistently through the book, varying speed of progress according to personal requirements for practice and pleasure.

acknowledgements

This book has in effect been written by my students; I should like to thank them, together with my husband, Charles Willink, and the many friends who have been so generous with their help, including my colleagues at the Berkshire College of Art and Design; also the staff of the galleries and other institutions who, with unfailing patience, have assisted me with selecting work for reproduction. I am indebted to the Department of Fine Art at Newcastle-upon-Tyne and Leslie Lawley for permission to base some of the design chapters on their work and to the many others whose ideas I have borrowed, consciously or unconsciously. Every effort has been made to trace owners of copyright; I much regret if there have been any omissions.

The paintings and drawings illustrated are reproduced by gracious permission of Her Majesty the Queen, and by courtesy of the Trustees of the Courtauld Galleries, London; the National Gallery, London; the National Portrait Gallery, London; the Wallace Collection, London; the Curators of the Bowes Museum, Barnard Castle, Co. Durham; the City of York Art Gallery; the Lady Lever Gallery, Port Sunlight, Liverpool; the Syndics of the Fitzwilliam Museum, Cambridge; the Provost and Fellows of Eton College; and the Ashmolean Museum, Oxford; L'Association pour la Diffusion des Arts Graphiques et Plastiques; the British Museum, London; John Holder Esq.; Harry Holtzman Esq ; Kettle's Yard, Cambridge; the Monotype Corporation; the Scottish National Gallery of Modern Art, Edinburgh; Société de la Propriété Artistique et des Dessins et Modèles; Southampton Art Gallery; the Tate Gallery, London; the Victoria and Albert Museum, London; Edward Ardizzone; Nancy Baldwin; Edward Bawden; Wilfrid Blunt and Will Carter; Gordon Cullen; Paul Hogarth; Lynton Lamb; Ada and Emil Nolde; John Piper; Bridget Riley; Mrs. Wyndham Lewis.

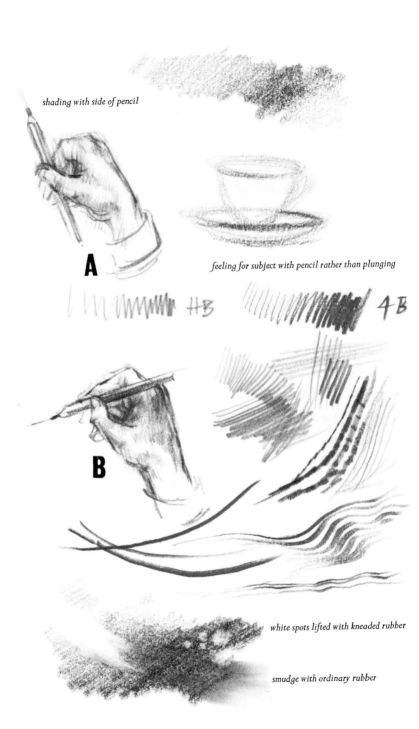

shading with side of pencil

A

feeling for subject with pencil rather than plunging

HB

4B

B

white spots lifted with kneaded rubber

smudge with ordinary rubber

1 PENCIL

finding out what you can do with it

materials:
varying grades of pencil—HB, 2B, 4B
drawing-board—wood, width to carry comfortably under one arm
medium soft rubber
'kneaded rubber'—soft malleable; made specially for drawing
fixative—see page 1 2 8
smooth, white paper for preference

High on the list of pleasures from drawing and painting is getting to know the possibilities of different materials—finding out the various effects that can be produced. The first section introduces the most commonly used materials alongside appropriate subject-matter. Whether you prefer pencil, pastel, pen or paint is for you to decide; but it is well worth trying out as many materials as possible. Everyone in their time has misguidedly shaded in yards of grey pencil smog in place of some coloured background, or struggled to paint the morning mist with three basic poster colours. Choose the tools to suit the subject, or choose another subject: for it has got to be worked out in terms of the medium you have chosen—that is, in terms of those particular materials.

Experimenting with pencil, and learning to exploit it, is exciting. Make a row of experimental patches of different kinds of pencil marks—not necessarily pencil strokes, for that would imply holding the pencil only in a writing position as in fig. B. (A and B illustrate the two different holds.) A lot of fun can be had, fig. A, by rubbing the side of the lead on the paper to get various widths, tones and textures. Try sharpening your pencil to a flat blade as an alternative to a point. Experiment with different grades of lead—HB, 2B and 4B make a good range. Use a kneaded rubber creatively, not unlike a loaded brush of white paint, by pinching it into a point to lift out the areas of white; or smudge a pencil stroke into a grey streak with an ordinary rubber—you will probably need to practise. Do not rub out a line because it looks wrong. Leave it; it will prevent the mistake from being repeated, and will help to make the drawing look free and spontaneous.

(sketch unfinished to show pencil approach)

3 UTRILLO La Porte Saint Martin *Tate Gallery, London*

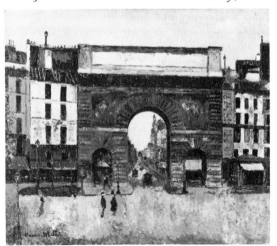

tone values *the relative lightness or darkness of a colour*
Quite different colours can have the same tone-value,
appearing the same shade of grey in a black-and-white photograph,
e.g. red and green in certain mid-tones,
best judged by looking through half-closed eyes
when colour will be reduced mainly to tones of grey

monochrome *rendering in tones of one colour*

putting it into practice

Work from the colour reproduction, preferably larger than postcard size, of a painting you admire. This is a chance to study carefully the work of someone like Utrillo or any great painter. Avoid a portrait, where the problem of getting a likeness may bother you. If possible choose a picture that you can go and see soon afterwards; you will find your appreciation of it has increased.

An exact copy is not possible. In the different medium you are using, the *monochrome* drawing will have to translate the colours of the painting into light, dark and medium shades, or *tones*, of the graphite lead of your pencil.

Neither is an exact copy desirable, for a rethinking in different materials from the original is bound to, and should, look correspondingly different. Manet copied Titian's 'Venus d'Urbino' and used almost the same pose later in his own painting 'Olympia'. Working from a reproduction at this stage is helpful, as most of the planning has already been done for you.

Work out where the results of your previous experiments can be used. Make a plan and stick to it, even if in the middle stages it looks unpromising. Starting afresh could be wasting time, with the second drawing following a similar course and producing the same sort of problem. Build on experience by taking the drawing through to a finish, and learning early not to be put off. Start the drawing in an area that interests you particularly, and move outwards using pencils and rubbers as imaginatively and freely as possible. Try to get the effect you want directly, drawing strongly and vigorously without reworking. It is of little importance whether you tackle all or only part of the painting; but it is important that you should enjoy what you are doing. This is what makes a good drawing. Avoid unintentional smudging by spraying the finished drawing with fixative, but not until it is complete. Pencil cannot easily be removed after fixing.

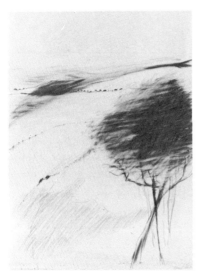

4 NANCY BALDWIN pencil landscape

enlarged detail of foreground showing use of rubber

enlarged detail of horizon showing smudging

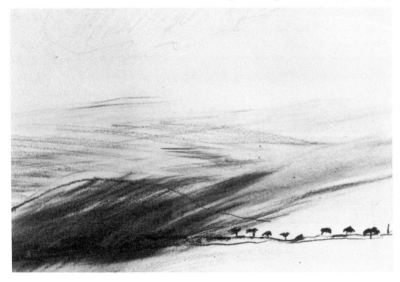

DRAWING MATERIALS DEFINED

Only experiment can tell you which of these materials, mostly quite cheap, you like the best.

carbon-pencil—pages 31–33 soft, black, producing a similar texture to that of eighteenth-century pencil drawings.

chalk—page 16 a misleading term which strictly should refer only to the base used to bind pigments or to drawing material for blackboards, though often used to describe soft, coloured pencils

charcoal—page 178 specially prepared residue of burnt wood; brittle; only in black; needs spraying with fixative

conté—page 15 short for conté chalk; manufactured in the form of square sticks, usually available in dark brown, sanguine or terra cotta red, black and white; brittle but not powdery, slightly harder than pastel; drawing should be fixed

crayon made of chalk or pipe-clay in various colours; nowadays usually intended for children; term originally used before the eighteenth century to describe pastel

oil-pastel—pages 97, 127 twentieth-century product where pigment is bound in a base which contains oil; usually in a basic range of colours; much easier to handle than ordinary pastel; allows thick, layered (impasto) surfaces to be built up — cf. oil paint

pastel—page 107 pigment mixed with chalk, in an enormous range of colours and tones; comparable with paint especially in light tones; awkward to handle, very brittle and powdery — picture surface can become overloaded — fixative essential

pencil—pages 8–12 from Latin '*penicillus*', a writing or drawing instrument; formerly used also to describe a small, pointed brush; now taken to mean a blacklead (graphite) pencil

silver-point a very fine, silver rod possibly encased in wood, like a graphite pencil; requires specially coated paper; favoured by such masters as Holbein and Dürer

fixative a spray-on solution to prevent smudging (page 128)

a b c

5 *cylinder b has been flattened out*
by the use of tone on both sides
cylinder c has been made to look round by
the addition of extra tone on the right

7 *conté sticks,*
used sideways, allow
drawing in terms of
a broad band of texture
as well as a point

6a *still-life— drawing of form*

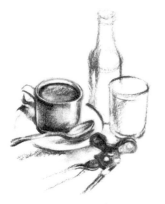

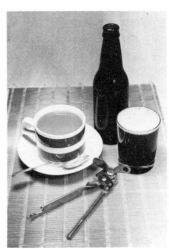

Bailey

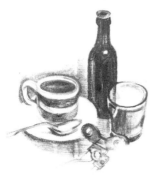

6b *still-life drawing showing colour*
in terms of tone

7

2 CHARCOAL, CONTE, PASTEL

different approaches to a subject

There is often confusion about these materials, and indeed about the difference between drawing and painting. Drawing is often thought to be entirely linear, produced by a moving point; while painting is held to be concerned with areas, and to result from the use of a brush. But drawing and painting are not separate activities, and certainly should not be divided up in this way. Opposite is a photograph of an everyday sight. Beside it are two quite different graphic interpretations. In the top one, modelling is added to explain the form or the three-dimensional shape of the objects. Light strikes the nearest surfaces or planes, and the remaining ones turn away at varying angles into corresponding grades or tones of shadow—see diagrams of cylinders. Beware of the word 'shading', which too often goes with a mechanical rendering of tone-values, and encourages the wrong approach. In the bottom illustration the interest in light ranks second, and it is the tonal pattern of the striped mug which holds the attention. Often the beginner starts on a subject such as a piece of driftwood, shades it all in to represent its colour—although it was probably the twisting form which caught his eye in the first place, not the colour—and then wonders why the drawing looks lifeless. By covering up all the white paper within the actual area of the driftwood— in other words by removing the top end of the tonal scale—the illusion of light falling on the rounded form has been destroyed. The tonal plan is without interest. Areas of plain paper should always be worked out in advance. Note the use of a heavier, darker weight of line for the nearest parts of the driftwood.

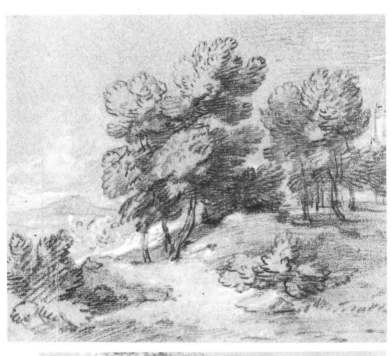

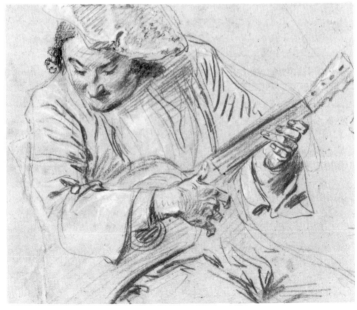

8 GAINSBOROUGH *British Museum*
black chalk with white pastel

9 WATTEAU *British Museum*
red chalk heightened with white

Both the illustrations on page 16 could be described as drawings because
they were carried out with what are technically referred to as drawing
materials. However, both are concerned with aspects of interpretation
more usually associated with painting, with colour (in the top drawing)
and light (in the bottom one), and could well have been studies for a
painting.

On page 20 there is a pen-and-ink illustration of a twig from a fig-tree.
It is the concern with structure which makes it essentially a drawing,
not the nature of the medium. Similar information could indeed have
been given with a brush, but on a larger scale. Drawing and painting are
complementary aspects of the same idea. It is not necessary to learn to
use a pencil before picking up a brush.

two colours on a tinted paper

Conté comes in several colours, and the pastels come in many more.
Though paper is made in only a few sizes and relatively few surfaces,
there are many different shades. It would be fun to set out to enjoy them
all to the full, and might well prove very rewarding. But, to start with,
limit your choice to a light-toned, tinted paper with a slightly textured
surface, a carbon pencil and a white pastel which will contrast with the
colour of the paper. Gainsborough and Watteau kept the use of white
to the absolute minimum, while using it in the two different ways
described above, Watteau to highlight form, Gainsborough to represent
the lighter colours of the distant landscape and sky and even the path in
the foreground. The use of full colour in pastel is discussed on page 127.

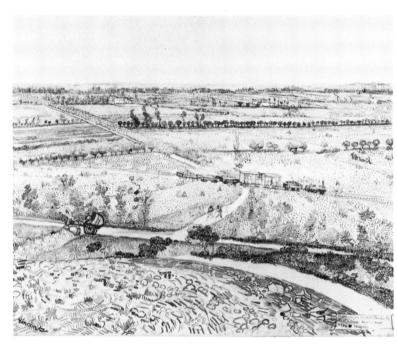

10 VAN GOGH *British Museum* pen drawing; below, approximately original scale

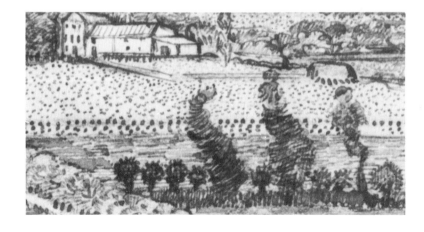

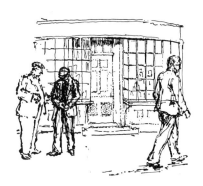

11 LYNTON LAMB
The English Provincial Town
Eyre and Spottiswoode

3 PEN AND INK

materials:
paper *smooth, white; good cartridge, hot-pressed or bank (page 114)*
pen *never cheap ball-point (smudges) or mapping nib (scratches)*
dip holder and metal nib, as long as possible for pliability
stylo-type pen (for constant, even line)
reed/quill (feather)—split the bottom slightly, trim at an angle
felt-tip—possibly the modern equivalent of reed/quill (page 128)
ink *Indian—waterproof or ordinary—gives a dense line*
fountain-pen ink, non-waterproof and less opaque;
avoid brilliant ones which dazzle and distract.
Try using two different inks in the same drawing—
brown with black for emphasis, but see page 128 on permanency

You may at first be worried by the fact that ink cannot be rubbed out; but you will find you can use it just as well as any other medium to explore your subject. In the illustration by Lynton Lamb above, the figures are clearly superimposed upon the sketch of the shop-fronts, with an effect of spontaneity. Pen drawing gives you a stimulating sense of professionalism, and excitement comes from the strong tonal contrast of ink with the paper—bubbling out onto an unblemished, white surface.

There are as many ways of using pen and ink as there are subjects to draw and people to draw them, evident from the examples on this and the following pages. Van Gogh's drawing opposite was made with a soft, wide point—he often used a reed—and it gives an idea of the variety of texture, 'pictorial shorthand' or pattern, that a thick line can produce to describe a landscape. Referring to this magnificent drawing as a sampler greatly undervalues it, but it is worthy of special study from this point of view. A pen-line can make a very precise statement if wished, and, contrary to general opinion, can prove a very salutory method of studying form. Choose a branch with some leaves on it— something with good, sculptural form such as an apple-tree, or better

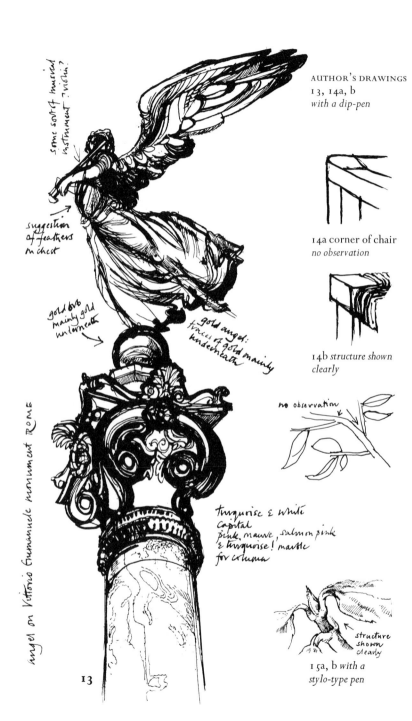

some sort of musical instrument ? violin ?

suggestion of feathers in chest

gold orb mainly gold underneath

gold angel: traces of gold mainly underneath

turquoise & white capital
pink, mauve, salmon pink & turquoise! marble for column

angel on Vittorio Emanuele monument ROME

13

AUTHOR'S DRAWINGS
13, 14a, b
with a dip-pen

14a corner of chair
no observation

14b *structure shown
clearly*

no observation

15a, b *with a
stylo-type pen*

structure
shown
clearly

16 BEARDSLEY the Wagnerites, detail
crown copyright: Victoria and Albert Museum
17 ARDIZZONE Back to the Local *Percival Marshall*

still, if you can get it, the branch of a fig-tree; this has clear growth rings and well-formed branching (15b). The eye sees what the brain tells it to see. In other words, you see what you have grown accustomed to expect. Try to look at everything as if for the first time, and draw it for someone who has never seen anything like it either. Explain how it grows, how it is made, how it works. This makes for a positive, confident drawing, for it will be based on observation; it has a reason for being made, as it has information to impart. If at the same time you can make use of specific pen-textures to interpret the subject, so much the better. On the opposite page is a working-drawing for a painting of a statue, emphasising the angel on top of its column, piercing upwards into space. Even with the ultimate goal of paint in mind, it is worked in terms of the medium in use at the time.

There are two pitfalls for pen draughtsmen. If the penwork becomes clogged, the drawing will become dead. (Penmarks can sometimes be erased by scraping carefully with a razor-blade and burnishing the surface flat with the back of a spoon or other rounded surface, before redrawing. Ink is not guaranteed to grip on top of white paint; indeed it will probably flake off.) The sparkle of the paper surface should show

18a *paper about to be immersed under water; note paper-tape already torn off, ready for use*
b *paper being spread flat on a wooden board, from the centre outwards, with a clean, dry cloth*
c wrong *tape has not been stuck equally to paper and board, or pressed into the 'valleys' caused by cockling of the paper when wet*
d right *correctly stretched paper with the tape stuck equally to paper and board; note the edge of the paper lies down the middle of the tape*

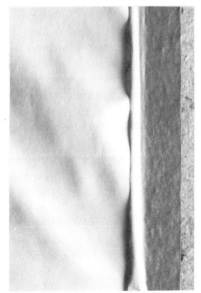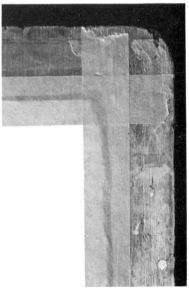

Greville Studios

through, if only slightly, even in shadow—note Ardizzone's drawing, previous page, and Paul Hogarth's (190). However, solid areas of ink can be effective if deliberately planned, as in the detail of Beardsley's drawing, (16).

The second pitfall is the practice of outlining and filling in; it is only successful in such skilful hands as Minton's (64). It is safer, like Ardizzone, to allow pen textures to make their own arbitrary edges as far as possible. This will have more chance of holding the eye than something more accurate but less spontaneous.

The medium of pen therefore offers two distinct advantages: an unrivalled opportunity for decorative tonal patterns, and the absolute clarity of statement which results from black line on white paper, with the maximum of linear contrast.

HOW TO STRETCH PAPER
to keep the surface flat when using watercolour washes

equipment: a smooth, wooden board *free of grease,*
at least 1″ longer in both directions than the paper to be stretched.
(Hardboard and cardboard will warp with the tension of drying paper)
gum-backed paper tape *not self-adhesive or waterproof tape*
as it must be subject to the same conditions of shrinkage as the paper
paper *cartridge (watercolour paper should not require stretching)*
sink, or bath, of water *in preference to a tap*
towel and dry cloth

1 Tear off four lengths of tape at least 2″ longer than the dimensions of the paper.

2 Immerse the paper in a bath of water; beware of the air-bubbles clinging to the surface of the paper, preventing the water from covering it completely

3 Lift the paper from the bath carefully, tipping the water off and checking against dry patches; lay it on a towel and blot up surplus moisture with a clean, dry cloth.

4 Spread it gently on the board and smooth out to be as flat as possible, working from the centre outwards; submerge the lengths of tape separately in water, and stick down the edges of the paper with them— if cockling occurs, make sure the tape remains in contact with the paper and the board along the whole of its length (18c, d) and make sure the tape is stuck equally to board and paper; dab up any excess moisture.

5 Dry flat, away from direct heat or sunlight to make sure of even tension; do not remove the paper from the board until the sketch is complete.

19 *Choose a good black-and-white photograph of a landscape. Avoid buildings with too much perspective. Feel free to interpret what the camera can merely record: ignore the awkward tree on the left and the dull foreground. The camera has registered the tone values of your subject—the way is clear to explore and exploit the possibilities of area as well as line.*

Rydal Water Cumbria The Times

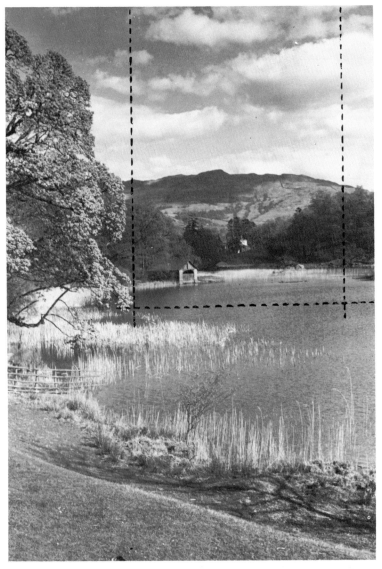

4 PEN AND WASH *part one: monochrome (one colour)*

materials:
pen (*page* 19)
ink—ordinary washable *ink dilutes well with water*
avoid too bright a colour—blue-black, diluted,
may vary in colour; it can be attractive
but some of the colour effects are fugitive, not permanent
waterproof or Indian ink *sometimes goes scummy if not diluted*
with distilled water, but it does not run under a wash
waterpot *preferably with a screw-top*
saucer or plate *unpatterned for mixing washes*
paintbrush *medium large, pointed, suitable for watercolour*
(not hoghair), see footnote iii page 29
sponge *rag or blotting-paper*
'tester' paper *to try out tone values of washes before use*

what to sketch

There are two things to consider before starting. In the first place
materials should always be suited to the subject; if you intend to use pen
and wash, a subject which is attractive on account of its colour is
unlikely to be good. Colour can be very deceptive. The effect of
weathering on stone often produces fascinating areas of green through to
golden brown; but the single colour of a bottle of ink, even when
diluted into varying tones, is not going to do justice to it. Look for a
subject where colour comes second to tone values, where there is clear
light and shade. Secondly, time is important. Five minutes is probably
long enough to sketch the detail of a Tudor chimney-stack; it is not
enough to do the whole of Hampton Court Palace. Alternatively, with
two hours in hand, it is worth while including in your drawing the boats
waiting to enter the lock as well as the lock-keeper's cottage and the
lock gates. There is nothing more disastrous than having time to fiddle
with a drawing after it is really finished—that is, when you like it or
when you have got all you can out of it in the way of experience. The
following plan for sketching with pen and wash is intended only as a
guide for beginners; it would be unwise to regard it as anything more
than a starting-point. If followed rigidly on every occasion, it could
produce very stereotyped results. However, it does work because the
unity of the result is virtually guaranteed by the steps taken to produce it.

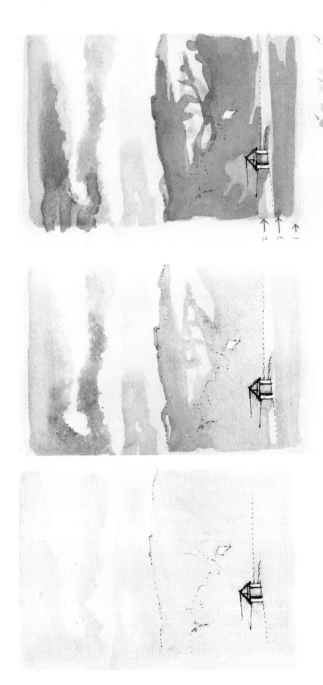

20 a first wash leaving out 'whites', paint all over the whole sketch
b second wash cover all the main, darker areas, massed together as far as possible
c third wash add 'darks' sparingly

Sketching with pen and three tones of wash

1 Sort out the areas to be left white as plain paper—clouds, distant white building, front supports of boathouse; do not hesitate to emphasize focal points such as the size of the house. Rough in the main outlines with a dotted line, and draw in any foreground buildings firmly with waterproof ink, as this gets the actual drawing started. At this stage pencil contributes nothing to the final result, and can divert the sketch misleadingly into a drawing which would be mostly lost beneath the later washes. A fine brush line in a pale tone, instead of pen, will do equally well.

2 *first wash* Mix by putting a little water with a brush into the saucer and then tinting it with a touch of ink. Keep it extremely pale and test before use. With this very pale wash, roughly paint over the whole of the picture, leaving the white areas out. Leave a decent margin of white all the way round the sides as well; to take the sketch right out to the actual or ruled edge gives a very tight, rigid appearance. The sketch needs air, page 121.

3 *second wash* only very slightly darker—be sure to test again. With this, paint in the main areas of darker tones, not hesitating at this point to merge hills, trees and figures into each other. Try to avoid seeing things of the same tone value as separate items if they are really massed together. The unity of the whole sketch must be achieved first before individual detail can be considered. Failure to do this will produce a jumpy, spotty look.

4 *third wash* medium-toned but still not dark, even if the area to be treated looks very dark-toned in the photograph. The ink line must be able to show up well against it later. Keep this wash simple and use it only where necessary—to bring out a figure, the side of a roof, a tree or other shape. In the example shown, though the wash is extensive, it is still uncomplicated. The original sketch was made the actual size of the reproduction on the next page, so that the layers of simple, flat washes could easily be distinguished. In practice, if including as much detail, it is much more satisfactory to work at least four times larger.

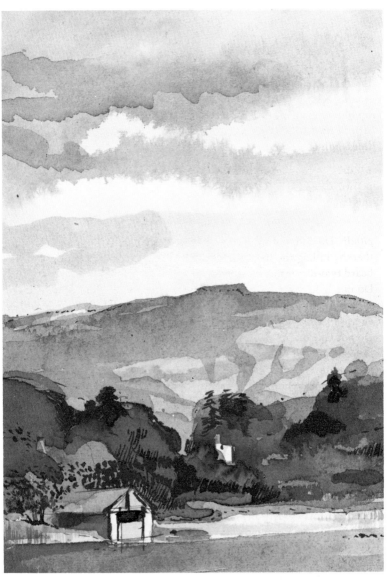

20d *pen and wash sketch finished by addition of extra drawing or brushwork as necessary*

5 *line* to define, emphasize or reassess the subject, not to draw evenly round every detail. Do not worry if the drawn line does not link up with the areas of wash (see hill-top, stage 2); freedom is more important than accuracy. Just as the first light placing-line in a pen drawing blends into the finished sketch, so the various stages will merge together to give a spontaneous result. Provided the line is informative and confident, based on observation, the sketch will not be complete without it, and there will be no danger of it becoming an unnecessary extra, e.g. construction lines of the boathouse.

6 *extra areas of wash* are usually needed at this stage, together with extra penwork, to adjust any parts that seem incomplete or unbalanced—in this case for the trees behind the boathouse.

pitfalls Do not outline areas already satisfactorily put in with wash, thereby killing the freshness of the brushwork and giving a tight, cardboard two-dimensional effect.

Do not let the washes get too dark too soon, or the line-work will not show up. With this in mind, study topographical drawings of the late eighteenth and early nineteenth centuries (81).

Do not take on problems of 'transposing'—radically altering the tone of the background or some other section of the subject. The imagination is not always as reliable as the eye.

footnotes i The blurring effects of a wash upon ordinary ink can be disturbing, although it can be used to good effect e.g. to integrate the drawing of trees in mist with the background wash.

ii Wipe mixing surfaces over with detergent, otherwise the water will form into globules. This applies to new paintboxes just as much as to old saucers.

iii Sable watercolour brushes, though very expensive, are excellent, and, if properly looked after, will last indefinitely. Mixed hair is adequate and cheaper until you know what you want. Try any brush out with water before buying it—a decent shop will allow this. Make sure the brush has some spring and will come to a point. If the hairs bend limply sideways in a lump when wet, the brush is not worth buying. Always rinse brushes thoroughly in clean water after use, and shake them into shape.

21 PRIMARY SCHOOLCHILD Mark Proctor
*compare the perspective of this drawing with that of
the foreground building in Lowry's painting (37)*

22 JOHN PIPER Ca d'Oro *Southampton Art Gallery*

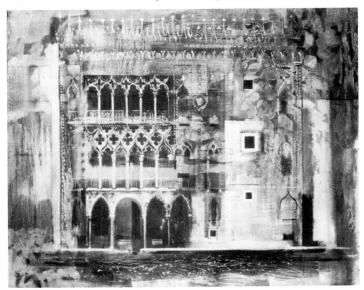

23a *'flattened' view* 23b *perspective view*

5 PEN AND WASH *part two*

how to tackle buildings—two approaches

Perspective usually heads the list of problems that a beginner feels he ought to tackle, and it is necessary to get the subject itself into perspective. It is an invention which has become a convention. Just as it is an accepted convention to shade one side of a cylinder to show that it is round—though there are situations to which this does not apply—so the rules of perspective are useful to describe distance or space, and in particular to describe buildings. There is, however, *no obligation to do so*. It may serve the purpose of the drawing better to ignore them altogether, either by arranging to draw the buildings sideways on, so that there is no diminishing perspective sideways, that is, at right angles to your line of vision (33d), as in Piper's painting of Venice (22), or to see the view 'flattened' as in a child's drawing, procuring an absence of foreshortening regardless of the angle made with the line of vision. This is not the time to question the reasoning behind the two approaches. Primitive painters, including those familiar with the rules of perspective, wishing to emphasize other aspects of painting, frequently and deliberately ignore them, as if the discoveries of Renaissance artists such as Uccello (150) had never been made. In 37 Lowry does just this. Oriental art, too, disregards the laws of perspective and of cast shadows—compare 139 and 57. Nevertheless, it is unsatisfactory not to be able to make the steeple rise from the centre of a church tower if necessary, and it is with this in mind that the rest of this chapter is written.

24 *eye-level* parallel horizontals meet at a vanishing point upon it

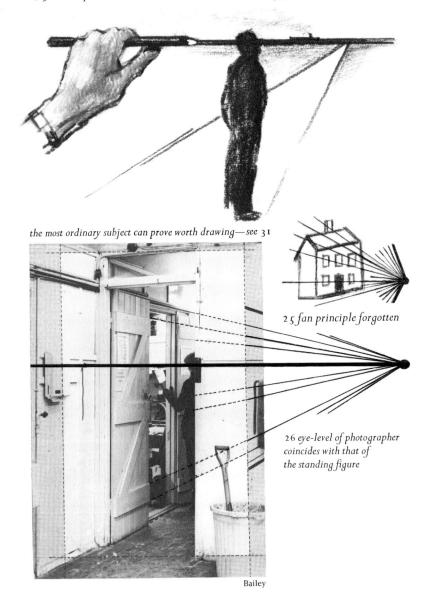

the most ordinary subject can prove worth drawing—see 3 **1**

25 *fan principle forgotten*

26 *eye-level of photographer coincides with that of the standing figure*

Bailey

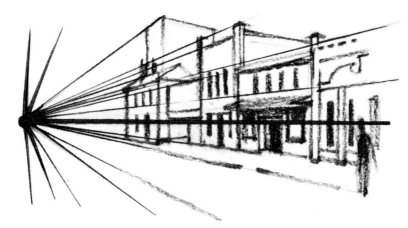

27 *fan principle* start at the nearest corner of any chosen building in order to judge the angle of perspective—lines *above* eye level go *down*, and lines *below* eye level go *up*

standing

sitting

28 *differing viewpoints*

eye-level and fan principle

These are the two elementary things to concentrate on. If the relationship of the observer's eye-level to the subject is not firmly fixed at the start, beginners tend subconsciously to take a somewhat aerial viewpoint—seeming to stand at a table when actually sitting, looking at a tennis-court from the umpire's rostrum rather than from the ground-level of the ball-boy, or, as in 77, gazing at a lake from halfway up a mountain rather than from the shore where they are actually standing.

Utrillo (3) was deliberately painting from a first-floor window. To find out where your eye-level is, hold a pencil horizontally across your eyes. Still keeping it level with your eyes, gradually straighten your arm out completely until the pencil is at arm's length. This is your eye-level. Note where it coincides with a horizontal in your subject, such as the sea's horizon, with a window-bar, as in the diagram above, or with a piece of boarding, as in the photograph opposite. Your eye-level should be thought of as the central spoke of a fan, and though the vanishing point, the radial point of the fan, may lie outside the area of your sketch, the position of the various spokes represent the fore-shortened angles of any other horizontals that may occur in the view.

cont. on page 37

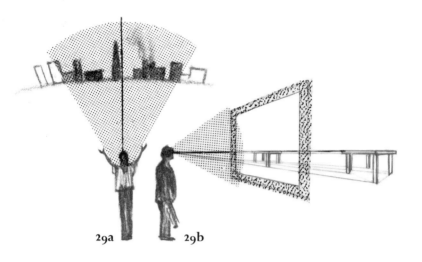

29a **29b**

29a the cone of vision *is approximately* 60°; *stretch your arms out straight in front of your body, move your hands out sideways until just out of sight—this is the width of your cone of vision*

the line of vision *lies directly down the middle of the cone of vision; verticals gradually slope sideways from this line (cf. photographs taken with a wide-angle lens)—this is barely noticeable within the range of the human eye—in 57b Spencer uses the whole width of his cone of vision*

29b picture-plane *(as opposed to an ordinary plane, see page 38) an imaginary, transparent plane or sheet of glass, corresponding with the surface of the picture, between the observer and the object, through which the cone of vision passes*

sight-size *the size the subject appears on the picture-plane—i.e. when diminished by the effects of distance (see also page 43)*

30 *when drawing an interior, e.g. the corner of a room, the temptation is strong to put in everything because it is 'near', regardless of the cone of vision—that is, the area of the subject which it is comfortable to include in a sketch, shown by the picture frames in the figs. opposite*

30a *if you want to get more in, move further away from the subject*

30b *if you do not want to include as much, move closer*

30c *what happens when relationships, e.g. floor to ceiling, and the measuring-unit are forgotten*

30d *satisfactory relationship between subject and cone of vision*

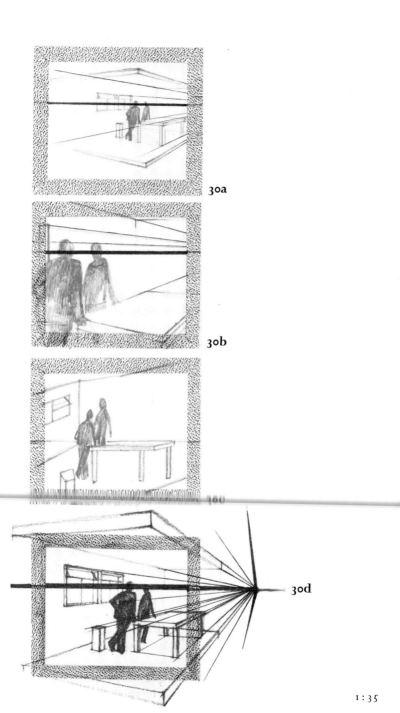

30a

30b

30d

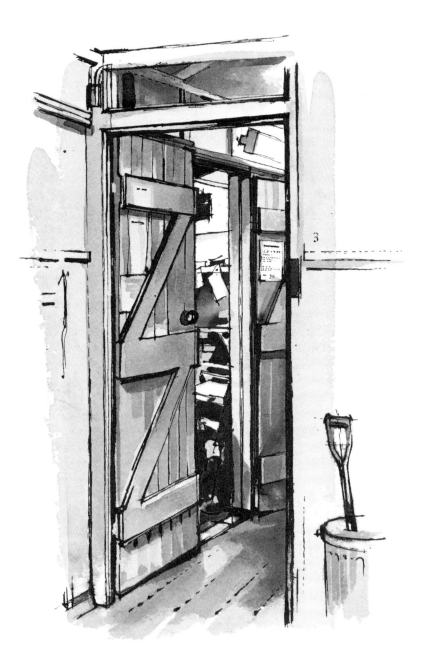

31 *pen and wash sketch of* 26 *reproduced two-thirds of its original size*

Provided that the fan principle is understood and applied, you need not worry about the more burdensome technicalities of perspective drawing, such as working out the exact position of vanishing points etc. For the average sketch, all you need is a measuring unit to gauge size and distance (page 43).

how to set about your drawing: controlling size and scale

1 *plan composition as if using a camera—upright or horizontal area? How much foreground and background? To experiment with different compositions, get a photographic slideframe or cut a rectangular hole, $1'' \times 1\frac{1}{2}''$, out of a postcard and hold it at varying distances in front of one eye. Stick two strands of black cotton horizontally and vertically so as to cross in the centre of this viewing rectangle*

2 *mark on the paper the total area of the intended drawing*

3 *with the aid of the black thread if necessary, pick out something horizontal halfway up the subject as planned in 1 (shelf inside cupboard just below door-knob) and mark this upon the paper*

4 *find a point upon this horizontal about half or one-third of the way across the total width of the subject (where the shelf meets the door just below the doorknob); this is the key point. Mark on the paper—the composition can now be keyed to the chosen area, so as to overcome the problems of fitting the whole subject on the paper or wasting masses of space round a minute drawing*

5 *find your eye-level (top of upper shelf) and mark it on the paper in relation to the key point and the edge of your drawing*

6 *select a particular distance to act as a measuring-unit which corresponds with this relationship—in this case roughly the distance between the shelves*

7 *from the key point, draw in the main features of the subject in terms of this measuring unit (e.g. width of near door+jamb = 2 units); see page 43*

8 *when the whole subject has been placed, strengthen the drawing and add watercolour wash (the illustration on the opposite page was developed on the tonal plan suggested in the previous chapter, combined with a strong pen-drawn framework)*

proportion and measuring unit

These instructions may seem complicated but you will soon find that they are logical and worth trying. The photograph on page 32 shows the relationship of the eye-level and fan principle to this subject, but the instructions above show that the drawing can be made satisfactorily using only the system of proportion and a measuring unit. The eye-level and fan principle is a means of double-checking, especially in the early stages.

cont. on page 43

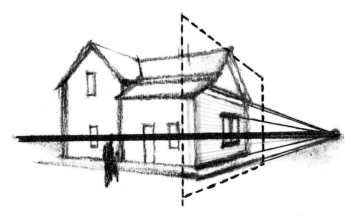

32a plane *the dotted line shows an imaginary, outsize piece of glass erected between the observer and one side of the house (not across the whole view, cf. picture-plane in 29b, page 34); this represents the plane of that side of the house—everything which runs parallel with that sheet of glass is in the same plane and the lines run to the same vanishing point*

32b change of plane *the other side of the house also has its own imaginary sheet of glass or plane, making a corner with the first one; this change from one to the other is called a change of plane; each plane has its own vanishing point on the eye-level of the observer*

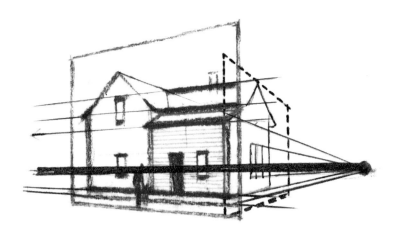

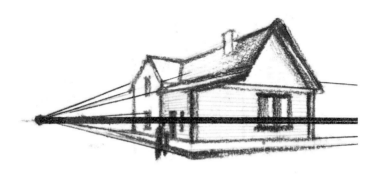

32c the position of the observer in relation to the house is different; the left-hand vanishing point is now nearer than the one on the right — as the view point of any one building changes (i.e. the observer moves) so do the positions for the vanishing points of that building, and for all other buildings as well

32d the more parallel the direction of the plane to the line of vision (e.g. buildings on the right of the view) the more exaggerated the foreshortening becomes

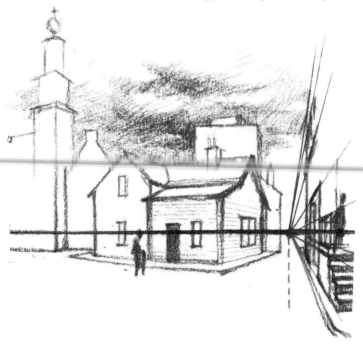

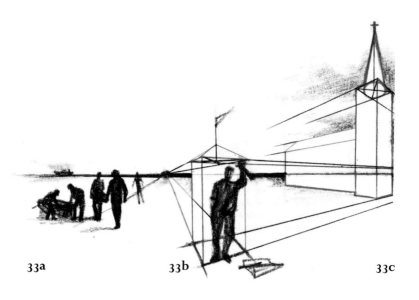

33a 33b 33c

33a *all individuals on the same level as the observer have the same eye-level but not 'foot-level'—heads and bodies of bent (or seated) figures are necessarily the same size as the figure standing beside them*

33b oblique perspective *the hut is turned at an angle to the picture-plane with two vanishing points, each a different distance from the hut—one close to the corner, one far away; interesting viewpoint*

33c steeples *draw the square, outer framework of the base in perspective; then draw in the diagonals—where they cross will be the middle—mark in the central perpendicular, draw in base (216b) and join up the sloping sides*

33d parallel perspective *the hut is exactly sideways on, or parallel to the picture-plane, with the line of vision down the centre; one vanishing point, needed only if a hollow view is shown—e.g. looking down the road through an archway (3); easy viewpoint*

33e *also oblique perspective, but in this case as the vanishing points are equally spaced from the hut, the effects of foreshortening are equal on both sides; dull view*

34 change of direction *the vanishing point is shifted accordingly along the eye-level*

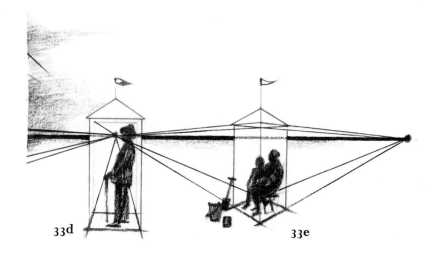

33d 33e

See appendix of further diagrams on pages 202, 203 for changes of level, angles of vision and the drawing of arches, circles and gables.

34

measuring up by running your thumb down the brush or pencil

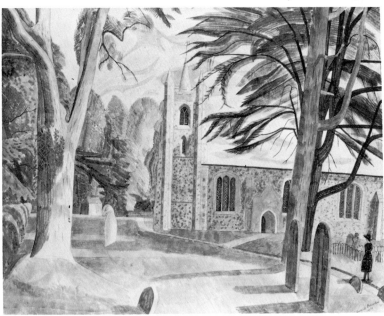

35 EDWARD BAWDEN watercolour (brush line and wash)
crown copyright: Victoria and Albert Museum

detail showing textures of foliage and stonework

measuring unit

Measurements must be consistent. This means that your arm must always be fully stretched when holding out the brush or pencil you are using for the purpose. Hold it out with the top level with the top of the upright you wish to measure and run your thumb down the brush until it lies level with the bottom. This measurement is known as sight-size, opposite; even when working sight-size, it is safer to relate distances in terms of measuring units made optically on a brush-handle and to *transfer these proportions* to your drawing, rather than using the actual physical measurements direct. Measure horizontals in the same way, holding the brush sideways. The important point to remember is that *the same measuring unit* must be used for horizontal and upright distances. In this way the relationship of the height to the width of the large doorway can be fairly accurately drawn. Thereafter it is a matter of checking as the jig-saw is put together (26, 31): the top of the spade lies not quite halfway down between the middle and bottom crossbars of the door itself, the bottom far corner of the cupboard doorframe is level with the top of the dustbin, the edge of the door by the doorknob, if extended upwards, would cut the lintel of the large doorway approximately in half, and so on.

6 BRUSH AND COLOUR WASH
introduction of figures

Colour is intoxicating, and therefore it is prudent to go warily and, to restrain its use initially to tinted washes. This limited use of colour was common practice with early British water-colourists (Cotman, 92). Watercolour is essentially transparent, and by obscuring this and darkening colour values this quality can be lost. Experience of colour for its own sake is often better gained in other ways, with other materials (Chapter 9). Tinted washes avoid the danger of sabotage to the tonal plan of a sketch by the introduction of sudden, violent colour. In other words the areas of wash should suggest their respective, natural colour, but with first consideration being given still to the patterned relationship between light and dark tones. Brushwork is used by Bawden to suggest textures of foliage and stonework, but he is careful not to let it upset the tonal balance of the whole. It is also worth bearing in mind, as Cotman did, that warm colours, such as brown, appear to advance towards the spectator, while cool colours, such as blue, have the reverse effect.

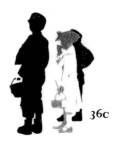

36a

36b

36c

three ways of showing the position of figures in a landscape
36a scale — see below
36b tone — see 91
36c overlap — see 1 2 3a

37 LAWRENCE LOWRY Canal and factories *Scottish National Gallery of Modern Art*

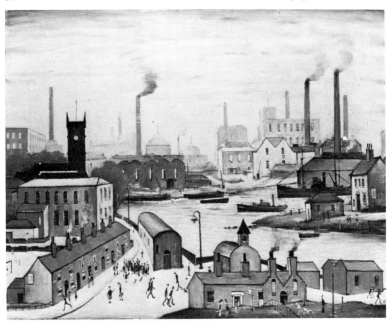

mixing a tinted wash

materials:
as for pen and wash, plus watercolours—
quality of paint is not important at this stage

aim for a soft neutral colour, possibly a sandy grey, and mix the tone of wash required in this grey before adding extra colour to tint it. As you gain experience, you will find that you can control the tone without first mixing the wash in grey

placing figures in a landscape

Approach figures in the same terms as landscape, of an interlocking pattern of light and shade. You can then afford to forget about the intimidating demands of portraiture or the need for deft action study. In fact, too much attention of this kind can intrude on the idea of the sketch and become inappropriate. A domestic interior or town landscape needs human inhabitants; and in more rural views as well, figures can help to give scale and distance, and possibly, by their anonymous quality, allow the spectator a pleasant feeling of identification. There are three standard ways of dealing with figures convincingly. A town park or square is the ideal place for sketching them; they form repeating patterns like waves on the shore—one or two and then several at once—something Lowry was well aware of.

scale Reduction in size has been used for many centuries to indicate distance, but it is only since the Renaissance that it has been harnessed to the newly discovered laws of perspective, to provide a source of technical satisfaction as well as an easily understood method of describing figures in space, demonstrated by Lowry as well as in Cullen's architectural illustration (39).

tone By seeing the figure primarily as a silhouetted shape, the tone value of the wash used for it can also show how far away it is. Seurat uses a dark tone for the foreground figures and lighter tones for the more distant ones (91).

overlap This has been used as a means of placing one figure in front of another since the days of primitive man and is a feature of Oriental art (119). Gordon Cullen uses it overleaf, to show the relationships between his foreground figures in the same way that the camera does (36c, 123a).

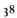
38

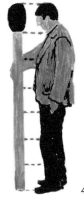

40a

40b

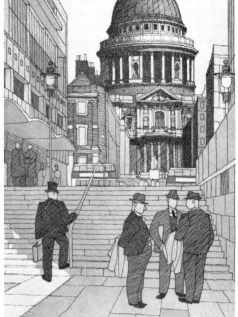

39

40c

The proportions of the human figure are worth fixing in one's mind. Too many beginners start by putting in an extra large head, adding a ration of arms and legs and then trying to insert the outline of a body in the middle. Try doing it in the opposite order.

Think of a matchstick as your starting symbol, even though this is understating the size of the head in proportion to the total height, normally considered to be about a seventh (Dürer, 195, makes it an eighth). It is nonetheless a useful mental image. Build up this matchstick shape as a solid silhouette, bearing in mind the bend of the body in movement. Overstate this angle; it always gets modified eventually. Imagine the age of the figure, its way of life and overall shape plus any associated objects (shopping-trollies, children, bikes, dogs, rucksacks or the like). Do not sketch arms and legs separately, but allow them to grow out of the silhouette as seems proper. If an arm is lying across the body, it is often not possible to make it out, and to try to show it weakens the impression of a solid figure. Remember to give seated figures the same sized heads as their standing counterparts; foreshortening of position only affects their height (198, 200).

With densely grouped figures, accept the results of overlap, which usually produces an intriguing, solid shape fringed with heads and odd elbows and legs; the numbers do not necessarily have to tally. Notice the solid shape and copy it with your brush, then add limbs freely to give the feeling of the rhythm of the group. Convincing individual details, such as the choice of particular coloured garments and patterns, are best left to the end. They are less important than the total plan, and are not immediately apparent anyway.

41 AUTHOR'S WATERCOLOUR Snow on Crossfell, Cumbria—detail
42 JAPANESE 19th C. watercolour of a cock *crown copyright: Victoria and Albert Museum*

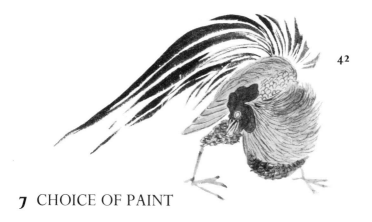

7 CHOICE OF PAINT

Watercolour is usually thought to be the most obvious choice for beginners because the initial outlay on materials is relatively small; indeed most people have a child's box dating from their own or someone else's schooldays. At first sight the medium seems straightforward. However it is deceptively simple; it offers no second chances, and requires confident execution and a well-developed sense of design (92, 93). Without these, the results can well be a timid and overworked attempt at Victorian realism (108), or a morass of expressionist brush-strokes, with colour watered down for safety's sake to a conventional symbolism of blue for sky and green for grass, regardless of weather, light or geography.

Watercolour has inspired the greatest painters, but it is not the medium to choose when starting to learn about paint and colour. That is why the previous chapters have recommended the use of a pen or brush line to provide a framework of drawing, and a unifying all-over wash together with a restrained colour scheme. Full watercolour, while traditional, is quite different from any other medium because of the need to keep its fundamental transparency, because of the change in tone as the washes of paint dry, and because it does not require anything but water to make a colour lighter. Full water-colour repays a reasonable outlay in artists' watercolour paint, good brushes and better paper; but for the beginner wishing to learn about paint, it is more sensible to wait, and, meanwhile, to buy a few tubes of students' oil paint with which more rapid progress can be made. Contrary to popular opinion, painting in oils is much easier. The paintings, opposite and above, show two totally different techniques of watercolour painting, which is dealt with more fully on page 121.

The detail of Palmer's painting opposite shows the use of thick, white body-colour to capture the richness of full-blown blossom—in contrast with the semi-transparent washes of ink in the shadow.
Overpainting with watercolour is possible when it is combined with the use of body-colour—nothing to do with flesh tints, merely the process of making the transparent colour opaque, usually by adding white.

43 PALMER In a Shoreham garden *crown copyright: Victoria and Albert Museum*

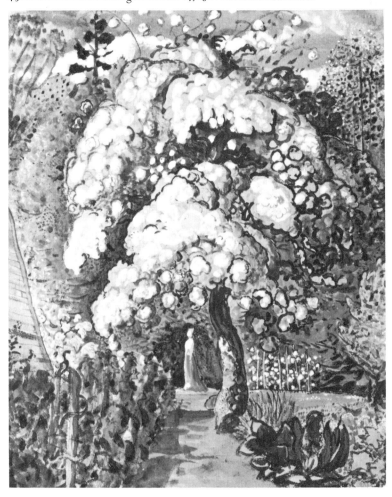

other waterbound paints

These are often included in the category of watercolour, but it is not strictly correct to do so. Painting in *tempera* is one such medium—difficult to classify as it is translucent, not opaque like other water-bound paints apart from pure watercolour. Based on an emulsion of water and egg, it is technically very challenging. *Powder-colour* and *poster-colour* are the crudest forms of opaque, waterbound paint. *Designers' colours* and *gouache* are made from more finely ground pigments.

The most versatile and popular alternative to oil paint, though not an equivalent, is *acrylic-polymer* paint, to give it its full title though it is often referred to by either word. It still suffers from the most trying property for beginners, a change in tone between wet and dry states, but otherwise its advantages are considerable. It is bound with an emulsion of oil and water which makes most of the effects of watercolour possible; but, with oil in its preparation, it can also offer opaque, impasto techniques. When dry it is certainly not water-soluble. Though it does not have the richness that comes from the luminous floating qualities of oil paint, this can to some extent be made good, if desired, by coating the surface thinly with some of the emulsion used in the making of the paint, and sold as 'medium'. But one must remember that it dries very quickly; in a hot studio or in the sun, it can be frustrating to have to cope with this, though it can be done. On the other hand the problem of transporting wet paintings does not arise. Individual circumstances must decide whether the ease of tonal control in oil paint, resulting from the absence of change between wet and dry states, is worth sacrificing for the convenience of acrylic-polymer. Experienced painters are not only unworried by the tonal change but, in some cases, definitely prefer the medium for its extra versatility.

detail from painting below

44 TURNER Two women and a letter *Tate Gallery*

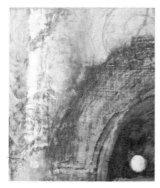

detail from painting opposite

palette knife and square-tipped brush

oil-paint

Some people are diffident about trying oil paint, not only because of the rather off-putting mystique which has grown up around it, but because of what it may cost. Oil paint is manufactured in two qualities: artists' and students'. A box of artists' quality oil paint, complete with brushes and canvas, is probably too expensive for most people, even without the cost of an easel, but this need not deter you. Students' quality paint is perfectly adequate for beginners; ·any old box makes a satisfactory container, and off-cuts of hardboard work out much cheaper than commercially prepared cardboard, and give a far more satisfying surface than cardboard or prepared paper. However to start with, a prepared board is the easiest answer. Hog-hair brushes are not expensive compared with sable ones for watercolour, and a basic range of six colours, page 61, is sufficient for a start. A smooth piece of wood or hard plastic will do for a palette—but it is worth investing in a palette or painting-knife. Oil paint will prove itself to be the most helpful medium to choose when starting to paint.

painting knife and round-tipped brush

The traditional painter worked on a mid-tone ground—coloured or tinted rather than white—which allowed him to work 'over' or 'under' in terms of tone value, contrasting darker or lighter paint with the ground. (Compare white grounds, where all tonal change is necessarily downwards, but where the ground gives maximum brilliance of colour.) On the tinted ground, modelling of the form was painted usually in a few simple tones—thinnish raw or burnt umber (dark brown) and light brown, and thicker white paint added last—rather like a monochrome photograph in effect. When this was complete, coloured glazes were added. Glazing meant diluting paint with oil, and applying it very thinly on top of the dry underpainting, creating a feeling of rich transparency (98). It was the secret of Titian's golden colour-schemes and Rubens' lustrous surfaces. The aim was to use thin transparent layers of paint for the shadows, thick opaque paint (impasto) for the areas on which light fell, and to cover all this with as many layers of glaze tinted with colour as desired.

45 ST URSULA detail from the 15th C. murals *Eton College Chapel*

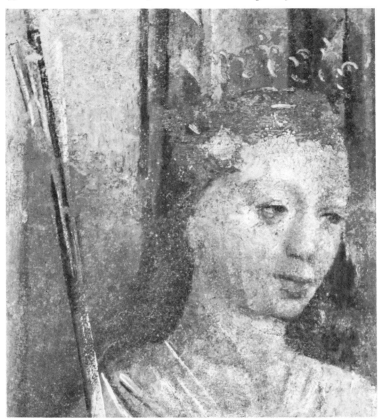

8 TRADITIONAL PAINTING PLAN
monochrome painting with coloured glazes – drapery

The use of oil paint is liberating for those brought up to believe that the ability to paint a flat wash heads the list of priorities. The following chapters are primarily concerned with oil paint, but include aspects of painting relevant to other mediums as well. It is worth remembering, though, that the full, rich, tonal shadows of still-life will normally be well outside the smaller tonal-range of watercolour, whose character is better suited to landscape. For those looking for a simple introduction to oil painting, and hesitant about colour, it is sensible to start with the traditional system of painting commonly practised up to the nineteenth century, before the advent of the Impressionists and before what might be called the colour 'revolution'. Renaissance artists such as Leonardo, had discovered *chiaroscuro* or the use of contrasted dark and light areas which in turn produced the technique of *sfumato* — 'smoky' — the imperceptible grading of light to dark. From then on, the major concern of painting was with light; colour was added mainly in final glazes.

The postponement of colour to a later stage in an oil painting can simplify things for a beginner, although for those interested in colour, it can seem very frustrating. The tonal plan of the picture becomes its backbone, something which often eludes those dealing in full colour from the start. In portraiture, particularly, a raw umber underpainting can be invaluable when striving to catch a likeness. However, glazing can be dangerous. It is essential to judge and treat the consistency and state of the various paint layers correctly. If a glaze is laid immediately over the wet underpainting, it will lift and sully the transparency of the glaze. The rate of drying for the underpainting is dependent upon such factors as the absorbency of the ground, and on temperature and humidity, and needs to be judged accordingly: paint thinned with turps dries quickly, paint thinned with oil may take three or four days. Too much linseed oil will trickle clumsily like a badly managed watercolour-wash, and this is where stand oil, thinned with turps, or one of the patent gels is useful, as they are heavier. As little oil as possible should be used. While the glaze is still wet, fairly thin paint can be worked into it, becoming part of the surface; once it is dry this is not possible as the heavier paint would press on the thinner glaze and eventually cause problems, like a sandwich with too soft a filling. Modern oil painting tends to turn its back on glazing, except perhaps in portraiture.

Nevertheless it is worth knowing about and remembering, for it can

modify a strident colour-scheme without obliterating the modelling and brushwork. A similar technique is often employed with acrylic-polymer.

what to paint on

easel All paintings need to be firmly held; start with a folding-easel which can be used for all but large studio paintings—there is considerable variety of design and price. It is up to the individual which to choose; the two essentials are stability and ease of assembly.

surface or support A prepared surface is necessary for oil-paint as ordinary paper is too absorbent; it draws the oil out of the paint giving it a greasy-looking halo. Commercially produced oil-painting papers have a very oily priming, are apt to tear readily, and can eventually turn brown. The loose sheets crease easily; the constant size, dictated by a pad, discourages experiment in the dimensions of one's work. Specially manufactured cardboard with a linen-type surface is probably the best answer at this stage. It comes in varied sizes—approx. 12 ins × 18 ins is the smallest sensible size to start on, assuming that the whole of this area is to be filled by the composition. It allows a still-life subject, of which drapery is almost invariably a feature, to be painted comfortably 'sight' size—the size measured optically, with outstretched arm—on the assumption that the subject is a sensible distance away for observation, that is, about three feet. Imagine yourself shaking hands with it. If one works smaller than this, there is a tendency to fiddle and overwork the paint, like a bad watercolour. Later it is cheaper to prepare one's own boards and canvases, pages 115, 117. If acrylic-polymer paint is being used instead of oil-paint, cartridge paper will do, but something stiffer, such as the thin board often used by fashion artists, is more suitable because of its rigidity and the absence of flapping edges. Ordinary cardboard is more absorbent than paper unless sealed. As with oil-paint, the best answer is to use commercially prepared board at this stage.

what to paint with

brushes Hog-hair brushes are pleasantly stiff; sable or mixed hair brushes are reserved for precise work where a fine point is required. Hog-hair brushes come with round or square-shaped tips—'filberts' and 'brights' are variations—see page 53—try them all: it is a matter of personal preference. Cézanne used a lot of square ones, as is evident from the reproductions (88, 90). Buy at least three different sizes: $\frac{1}{4}$ in., $\frac{1}{2}$ in. and $\frac{3}{4}$ in. approximately. As long as they are thoroughly cleaned in thinners, washed with soap and warm water and pinched back into shape after use, they will last, and a decent fistful of brushes can be collected.

Nylon brushes, with their softer texture, can be useful for acrylic-polymer paint, but are unsuitable for oil-paint as they easily become clogged with the denser consistency.

knives A palette knife is valuable for mixing paint—pigment mixed with a brush tends to work its way up the hairs to reappear as unmixed streaks of colour when least wanted. It can be used for applying paint, but is less easy to manage than a painting-knife. A painting knife is a more delicate instrument intended as an alternative to a brush for applying paint. As it is also more expensive, it should be kept for this purpose. If loaded carefully with paint along one edge, it is useful for making straight, firm edges, (105b).

thinners Turpentine and/or turps substitute (white or mineral spirits) is used by most students on grounds of economy; it is perfectly suitable for cleaning brushes, and can be used quite safely throughout a painting.

linseed oil Not the brown treacly stuff used for cricket bats, but the transparent version refined specifically for painting. Other oils such as poppy-oil are possible, but as linseed oil is the most practical and easily obtainable, it is the one recommended here—see page 118 for alternatives.

paint A basic list of pigments is given on page 61. For monochrome underpainting, flake white and a dark pigment, such as raw umber, are all that one needs.

dippers These are small round metal cans for oil and turps; manufactured singly or in pairs, they clip onto the side of the palette (page 6).

palette See pages 62, 69.

laying a tinted ground

Commercially prepared oil-painting boards are white. For the traditional method of painting described, this should be changed to a colour or tint; this is better done sufficiently in advance to allow it to dry, otherwise paint applied to the surface tends to pick up and be affected by the ground; this is even more important if working in full colour. Before starting a monochrome painting, mix up some oilpaint to the desired colour and thin it with turps to brush on lightly and evenly over the whole area. If preferred it can be rubbed on lightly with a rag. A cool, sandy colour is ideal—that is, a warm neutral of a mid-tone—but raw umber thinned to a medium tone will do. Paint left over on the palette can be used to mix up a tinted ground; it is economical and provides a very satisfactory surface; provided that the mixture does not contain too much red, it should make a fairly neutral colour.

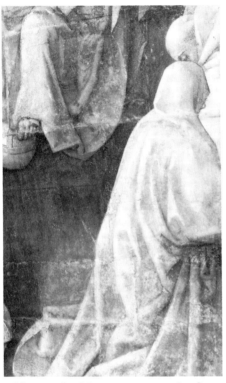

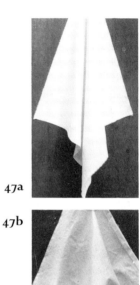

47a

47b

46 the Miracle of the Dying Woman, detail
Eton College Chapel murals

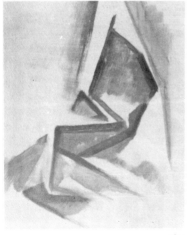

48a

48b

48a *On a mid-tone ground draw in the main lines and angles of the drapery with a lightly loaded brush of paint, slightly thinned with turps*
Fill in the planes of shadow in simple areas with the same paint
48b *Add white to the areas on which light is falling, i.e. the colour of the ground is left unpainted for middle-toned areas, as at the top of the drapery*
Develop modelling, softening abrupt changes in direction or tone by working or blending areas together, or by mixing tones lighter than the ground (adding a little umber to the white paint); do not thin the white paint with turps to lower the tone value—this gives a chalky look; keep paint consistency for light areas thick—this is known as 'loading the lights'; aim at the simplicity of approach shown; avoid overworking
To glaze with colour, the underpainting must be quite dry; use linseed oil, stand oil to which a little turps has been added or one of the patent gels manufactured for the purpose; for tinted glazes avoid opaque pigments, such as yellow ochre— other yellows are more transparent—use the minimum of paint; extra colour can be worked into the glaze while still wet though the fast drying properties of some patent 'gels' does limit the time available for this compared with oil; further glazes may be added when dry. Do not add anything but thin paint, or the glaze will not be sufficiently transparent to allow the underpainting to show through.

when to use turps and oil *the principle of 'fat' over 'lean' paint*
first stage Thin paint with turps—this gives a matt, fast-drying surface
middle stages Thin paint, as required, with equal parts of turps and oil
final stage Thin paint only with oil. Turps is used in the initial stages of a painting as it dries quickly and allows the maximum amount of work to be carried out in the minimum of time. Paint thinned with oil takes longer to dry, so it is added when the foundation of the painting is complete, when the light-reflecting properties of paint to which it has been added give greater richness of colour and quality.

Drapery as a subject has been enjoyed by artists as varied in approach as Wyndham Lewis (198) and the fifteenth-century painters of the Eton College Chapel murals reproduced in this chapter. It is not soft and formless and is subject to all the laws of gravity (47a, b). Movement in drapery is not gently curved but violently angled. Different materials show this with varying degrees of clarity. A soft, much-washed duster has feeble, blurred folds, while stiff silk produces a crisp 'geometric' look. A suitable piece of material thrown over a chair-back makes a good exercise. Do not arrange it specially—it can so easily look awkward and contrived; choose a fairly small section to paint.

49 CÉZANNE (detail from 88) Still-life with Water-jug *Tate Gallery*

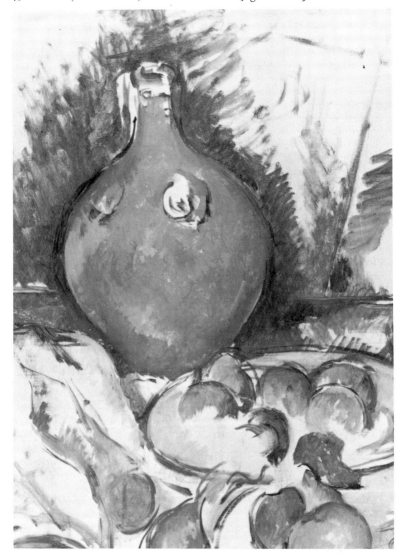

9 BASIC COLOUR MIXING— ALLA PRIMA PAINTING
finished surface arrived at directly— no under- or over-painting

Over the centuries still-life has proved a subject worthy of the attention of very many different kinds of painters. It is a good starting point. Watercolour is less suitable for still-life (page 55), so these chapters are written for those who use oil-paint or acrylic-polymer. Six basic pigments make up the foundation for the colour-mixing experiments listed on page 97.

Oil, with its greater light-reflecting properties, will give richer-looking results, and does not have the problems of change of tone between the wet and dry stages.

1 *a cool yellow*—it is not possible to specify a name that is constant for all makes and kinds of paint (page 96). Go for a 'lemon' yellow, not the more standard 'eggy' yellow which is warmer—warmth can always be added by a touch of red; it cannot be taken away. Beware of yellow paint which is opaque, i.e. has had white added. The best answer is to unscrew the cap of the tube if you can, and look at what you are buying.

2 *vermilion or cadmium red*—vermilion, though a traditional pigment, is largely replaced by cadmium red which is thought to be more per-manent. It is essential that the basic red should be a pure colour without a hint of bluish-pink about it.

3 *ultramarine*—even though it appears more purple than the primary blue of the spectrum (102).

Yellow, red and blue are the three primaries of the colour-wheel, or spectrum, and the specific pigments or colours mentioned above are what could be termed fundamental versions, in that they cannot be produced by mixing.

4 *alizarin crimson*—a purplish red which, from its position in the spectrum, one might expect to obtain by mixing a more primary red with a primary blue; in practice this mixture produces a warm brown; see colour charts, page 97.

5 *viridian*—the only green that must be bought; there is a case for describing it as a fourth primary. Greens should be mixed according to need—not used straight from a tube, which gives boring uniformity.

Technically these two extra colours approximate to secondaries, see spectrum, but they are included here in the fundamental range as it is impossible to mix them satisfactorily.

6 *white*—in oil-paint, flake white covers best, but alternatives are titanium white, more brilliant, covering well but drying poorly; and zinc white, which is colder, and unsuitable for underpainting, as it does not dry solidly. White is essential for colour-mixing in any opaque medium, i.e. other than watercolour. Note the muted, slightly cooling effect achieved by adding it to colours, especially in the darker tones.

arrangement of palette

Whether a traditionally-shaped palette is being used or any flat, smooth surface of wood, plastic or glass, it is best to put out the paint with some sort of plan in mind. Paint squeezed anywhere leads to khaki-tinted confusion. The traditional shape of a palette is the result of much experiment to produce a large mixing surface which will rest securely and lightly on one arm. Obviously, left-handed painters will need to reverse it.

Squeeze out 'reservoirs' of paint in the six fundamental colours as shown in diagram, page 6. Note that white is kept separated from the other colours so that if introduced into a mixture it is intentional, not by chance; note also that there is no black. The addition of black to a pigment deadens colour by moving it towards a monochrome grey. More subtle and exciting ways of achieving a darkened, tonal effect are discussed later. Always put out a little of all the six fundamental colours whether you expect to use them or not. The colour charts show how additions of the three primaries in differing proportions are essential for a truly varied range; otherwise a dull, monochromatic look creeps into the colour-scheme. Experience will show that a large reservoir of white is advisable, but an extremely small quantity of cadmium red will usually be sufficient. Paint left over can always be scraped on to a saucer or similar surface and kept from hardening for a time by immersing in water—or, as already suggested, used to lay a ground for the future.

colour charts—page 97

Before starting on an oil-painting, the best way to get the feel of the medium and its colour possibilities is to make your own colour charts. Paint for these is best mixed with a palette knife on the palette first. Kept in the lid of a paint-box these charts can prove a valuable reference when dealing with the colour relationships found within shadows.

thinking in terms of paint and colour

An excellent plan for one's first venture using full colour in oil, is to copy part of a painting like Cézanne's 'Still-life with Water Jug' (49, 88). However, this must be from a reasonably large reproduction with fairly faithful colour. (Colour slides are far too small unless projected; post-card reproductions are barely large enough.) There are two advantages. First, the shapes and brushmarks can be seen fairly clearly in 49 and it is possible to start thinking in terms of this particular medium and its application straight away with no false preconceptions derived from watercolour. Oil-paintings by artists before Cézanne tend to have such skilled and sophisticated finish that they inspire awe rather than understanding. Secondly, the subject is thought of in terms of colour from the start; areas of shadow are not just darker versions of the colour of the surface upon which they occur, but different colours in their own right. The same brush will probably be used to put in any one colour, but each different colour will need a clean brush. Until a fair number of brushes have been collected, you will have to clean them frequently. Wipe them clean before rinsing in the dipper of turps and wiping again, otherwise the turps will quickly become sludgy and dirty. Do not try to tackle the whole painting at once, but choose a detail and work outwards from it. Cézanne usually worked upon a white ground or surface, and it is simpler to do the same. Avoid thinning the paint unless it is too stiff for comfortable colour-mixing. This approach to painting, of going straight for the finished surface, is often referred to as *alla prima* painting, and is in complete contrast to the traditional method of the previous chapter. Colour and tone are assessed at one and the same time, with no deliberate over- or underpainting. It is worth noting that once the main areas of colour have been blocked in and the colour of shadows mixed and added, the practice of 'painting through', that is blending one colour into another on the painting itself with a relatively clean brush, can be useful.

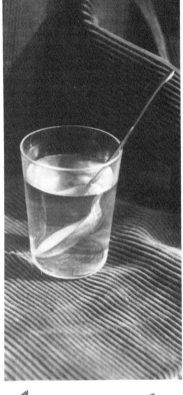

50d note tonal passage between the 'dark' in the surface of the water and the far side of the glass

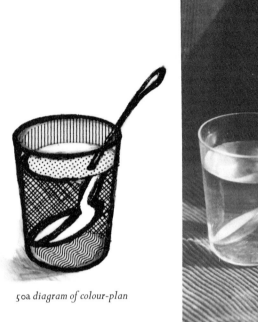

50a *diagram of colour-plan*

50b *positive shape of spoon* 50c *negative shape of spoon*

10 SHAPES

transparent materials, highlights, reflections

how to look at them

Shape has been defined by contrasting it with form. In painting, shapes are not necessarily tangible things. Half-shut your eyes; the details become less apparent and the main shapes more obvious. Equality of tone —tonal passages, see 50d —and other optical factors can produce shapes that are completely irrational but none the less visible. The shapes caused by refraction, distortion of the spoon in the photograph opposite, are an obvious example, exciting to observe and paint. In judging the shape of the bowl of the spoon, not only is the tangible, positive shape of the spoon itself relevant, but the negative shape of the space left round it (fig. bottom left). Awareness of positive and negative shapes is important —note Morandi's concern for this (52).

'colour-filter' system

Transparent materials such as glass or chiffon act rather like a colour-filter on what is seen through them, page 109. The detail is still visible, but the colour is seen as if through the lenses of sunglasses, tinted a particular colour. Even clear uncoloured glass has an effect on the colour of objects seen through it. Put an ordinary glass of water in front of a piece of soft, dark red material. The various, transparent thicknesses of glass and water have different effects upon the colour. Study the way the colour changes: look up the reds in the colour-mixing charts, and, remembering that cool colours recede, make a colour plan. First allocate a range of reds for the back drapery on either side of the glass, possibly using the cool blue-tinted ones gained by mixing alizarin crimson and ultramarine. Now select colours for the drapery where it is seen through the glass—one for each differently shaded section of the diagram (50a) opposite—basing them as far as possible on observation, although imagination or invention may have to fill in any gaps. This range of reds might well come from the brownish shades made by mixing cadmium red and ultramarine.

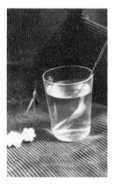

51a *bad composition—*
objects not linked,
hole in centre

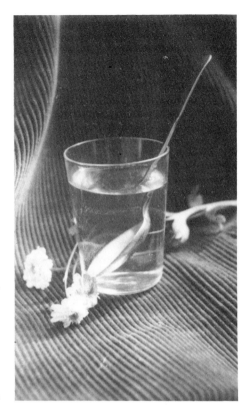

51b *improved composition*
(despite problems of focus
for the camera—
something the painter is spared)

In addition to the contrast of texture and shape in this very simple group, there
are the following colour contrasts:
material *dark, cool reds;* flower *shades of pale pink (mixed with all three*
primaries, see charts); flower-leaf *greens, light and dark;* glass *reds of back-*
ground 'filtered' to warm shades; spoon *light and dark variations on grey (see*
charts).
Greens could be contrasted, warm for the nearer and cool for the further leaves.
A colour plan of this sort helps the beginner—who usually sees shadows as plain
grey—to use colour purposefully.

When starting to paint, draw in the shape of the glass and the main lines of the drapery with a brush of dark red paint. Fill in the colour of the drapery in the background and foreground according to your colour plan, leaving out the area of the glass. *Do not paint the glass itself—* forget the reflections and highlights altogether; instead, paint the coloured sections of drapery as framed by the glass according to your plan. The use of colour in this way will produce a feeling of transparency without the need to rely on the glitter of highlights.

To make the painting more challenging, lean a spoon against the inside of the glass—balancing the composition with a pink flower laid beside it. Immediately the exciting optical results of refraction—the dividing of the spoon in two by the water level and the consequent side-stepping of the lower half—become worth observing and including. It is not possible to mix 'silver' paint for the spoon. It is made up of shapes of reflected colour, often quite isolated, and usually involving maximum contrast of dark and light; it should be painted so. Start with the dark shapes—observe and record them positively, before thinking of them in terms of tonal passages which will occur—where the paint can be worked across from one area into another, 'painted through', cf. Vuillard's jug (61). Ignore any ugly, trellis-like reflections of windows or window-bars which may prove distracting. Concentrate on a few high-lights, placed to explain the form—on the nearer side of the rim of the glass, not on both sides even if this is actually the case. Mix the off-whites for these with care, otherwise the effect may look like a dusting of Christmas glitter. Finally, think about the pastel colours of the flower. Thicker paint for the petals would be more than justified by contrast with the smooth transparency of the glass, where richer paint, thinned with oil, may well have been used in the final stages.

reflections

In a looking-glass or in water these can be treated on the same colour principle: imagine in either case that the reflected image is painted in the same colours as the original but viewed through a tinted lens or filter. In 99, Ingres uses a brownish-green tint. The essence of all this is the relationships between the colours, which remains the same, though carried out in terms of a suitably modified colour scheme. This modification of colour is completely different from the 'transposing' referred to on page 29.

choosing what to paint:

GOOD *all natural objects, veg., fruit, fish, etc.*
 objects made from natural materials — wood, leather, woven material
 simple-shaped objects — e.g. bottles
 BAD *imitative objects that offer second-hand information such as*
 painted china or plastic flowers, glass fruit, etc.
 fussy-surfaced objects — beaten-copper souvenirs

Two or three objects against a simple background of plain material are preferable to an involved group on a highly polished table. Plan contrasts of shape, of colour and tone and texture; as well as Morandi's painting below, study 61.
A collection of 'bits' assembled by chance, as they appear in Vuillard's painting (61) may suddenly catch the eye. Do not try self-consciously to improve them, or the lighting conditions, or the viewpoint, but get down to the subject just as it is. Think of the picture as expressing what caught your eye in the first place.

52 MORANDI Still-life *Scottish National Gallery of Modern Art*

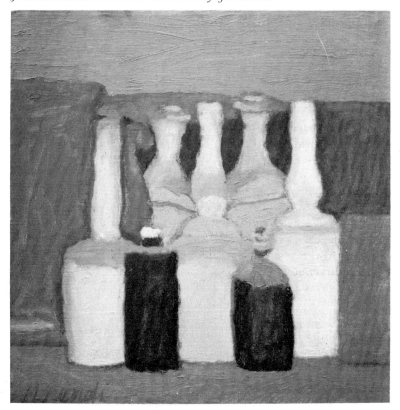

11 FOUR-STAGE PAINTING PLAN
choosing and composing a still-life subject

composing a still-life painting

The subject has been chosen and, if necessary, its elements assembled; but the painting still has to be composed, otherwise a vast amount of uninteresting background can creep in just because it has to be there for reasons of support. Use your viewing-rectangle; it will help to avoid the dead triangle of drapery at the top and too much space at the bottom and sides of the picture. Avoid unoccupied space, a 'hole', near the centre of the painting (51a). Remember that normal practice is always to look from left to right across a painting, as for the page of a book. A single fold in the drapery, or a knife propped against a plate, can provide a satisfactory pathway into the picture for the eye to follow. Concentrate attention on the subject; if this is a potted plant or vase of flowers, do not surrender the bottom half of the picture to the flower-pot, which is only a practical necessity. With long-stemmed flowers such as daffodils, it is even more advisable to put the vase on the floor, so that the stems are foreshortened, and, as you look down on them, the major part of your picture is occupied by the flowerheads (82). If you bear these general guidelines in mind and use a viewing-rectangle, arranging a still-life subject is straightforward.

four-stage painting plan

1 Look at your subject and decide on the basic shadow colour—a warm, sandy grey, perhaps. Avoid white when mixing it—yellow is almost as light-toned—as this tends to make the whole painting opaque from the start. Mix paint for the shadow colour on your palette; add a little turps with a brush to thin it to drawing consistency, and draw in black in the main outlines of the composition with it on the board or canvas.

2 Now get a basic coat of paint over the whole picture. Judge the dominant colour of each part, and its tone; mix it on your palette, testing it with a dab on the picture surface before use. It will appear much darker on a white ground than on the darker wood of a palette; there is a good case for using a white, plastic surface in preference. When mixing, start with paint nearest in tone to the colour you want— i.e. start with yellow, not blue, for a light green, or blue, not yellow, for a dark green; otherwise you will need quantities of the opposite colour to restore the balance. It may prove easier to cover the larger areas with paint by spreading it fairly thinly with a knife; do not try to

54

53a *photograph of original group*

53b *main outlines blocked in*

53c *basic coat of paint to show individual colour of objects*

53d *addition of darks*

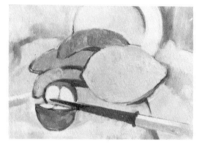

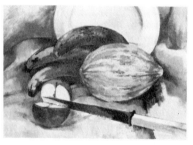

53e *close-up of central section—after addition of 'lights' (texture under melon)*

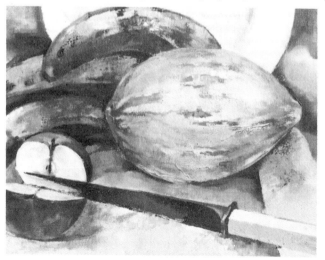

mix up enough paint to cover the whole area at once as if with water-colour. Enjoy remixing the colour, allowing it to modulate or vary slightly (88). When learning to work with oil paint, it is generally much easier to use unthinned paint provided that, like most students' quality oil paint, it is moist; there is less danger of falling into a water-colour style which prevents one exploring the real possibilities of colour.

3 Paint in the principal dark areas. Shadows need to be thought of separately in terms of colour, not just as darker versions of the same colour. Refer to the colour charts. Study Cézanne again (88) for ideas about colour in shadow—the shadow on the right of the flask is a brownish green, whereas the shadow on the other side is a blue-green.

4 Now paint the areas of the subject on which light is falling, using the same approach to colour as before: think of the colour of the 'lights' individually and carefully, as with the 'darks'. Do not assume that all that is necessary is to add white to the main colour of the object being painted. The colour charts proved that even pastel colours require at least a touch of more than one primary to avoid 'cheap' unsubtle colour.

Compared with watercolour, where work must move consistently from light through to dark, this is a totally different approach. Oil painting on a white ground requires the middle tones to be blocked in first; the 'darks' come next, followed finally by the 'lights'. The subject must be handled from the beginning in terms of oil-paint, rather than imitating watercolour—even though this may, by being familiar, at first seem easier; in the end it will frustrate your progress.

The painting is now fairly complete. Finishing touches are decided by what the painter wants to say. The following pointers may prove useful: Choose the size and shape of brush or knife used, to suit the mark required; note how the foliage in Cézanne's painting in 88 is coloured in these terms.

Paint shadows and objects at the same time. A shadow cannot exist without the object causing it; there are close relationships of colour (54). Keep the whole painting going. Try not to finish one part ahead of the rest. Always be prepared to wipe the mixing area of your palette clean at any time. Once mixtures containing white paint have been made, it is almost impossible to mix a clear colour.

It is no good trying to paint detail into thick, wet paint. If necessary, blot up the excess or scrape down completely.

Finally, if continuing a painting over a number of sessions, make a note each time of what is to be done next.

55a *landscape shape*

55b *portrait shape*

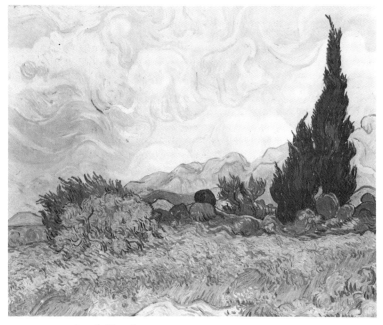

56 VAN GOGH Cornfield with Cypresses *National Gallery*

55c *choice of axis, or which way to work*

a square is unexpectedly difficult to compose and best avoided

55d 2 × 3 *shapes are good but try these as well*

foreground — a mere strip or most of the picture

12 COMPOSITION IN LANDSCAPE

viewpoint and content When painting outdoors, most beginners are too overcome by their panoramic vision and too absorbed with reality to give more than token consideration to the question of composition. The viewing-rectangle can be even more helpful when designing a landscape than when composing a still-life group. The viewpoint should be chosen to emphasize the essence of the subject—the ingredients that make this particular view special—and not governed totally by convenience; however, there is a good case, other things being equal, for choosing the view from the shelter of the gateway rather than from the middle of a field of cows. The viewing-rectangle can help to decide whether to have, for example, a tree in the foreground partially or fully included. Held at varying distances from the eye, and at varying levels, it changes the depth of the foreground from a mere strip to a large section of the painting; likewise the area of the sky. The position of some major feature, especially the sky-line, in relation to the depth of the picture area will decide which way to work, figs. opposite. Think of the two-dimensional shapes of what you are looking at; form does not become relevant until one gets to the individual ingredients of the landscape.

colour scheme It is worth remembering that colour and tone can be chosen, just like the viewpoint, to contribute to the idea of the painting. A beginner settles down to paint faithfully what he sees, and he is dependent on what the weather is doing. It is vital to sum up the atmospheric effect that is wanted, and deliberately to choose a colour-scheme which will express this, and can be carried out even though the lighting may change. Most colour-schemes are best chosen intuitively, but it is a good idea to examine them remembering that colour cannot exist without tone. It is not sufficient to decide simply on green for grass; think rather of light or dark green, in terms of tone; then the tone of the grass, as in Cézanne's painting (90), can merge with that of the brown tree-trunks in the shade, or contrast with it, as it does in the sunlight beyond the trees. Whether the grass is seen to be a warm or cool green, it can still keep the same tone value—see colour charts.

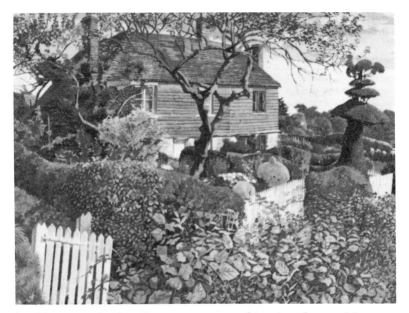

'Light' was introduced in Chapter 2 as a means of describing form, and Spencer has used it effectively on the topiary and tree-trunk, above. Light changes with the weather and that can be the main consideration in making the tonal plan for a landscape; light and shade should be used to help but need not rule the composition; there is no code of conduct which maintains that all the details, resulting from the effects of light, have to be recorded accurately, any more than it is necessary to include every telegraph pole or litterbin which may appear.

57b whole painting

58a diagram of 56

57c diagram of composition

58b diagram of 60

lighting was implied in the discussion of reflections and highlights and has been considered so far only as an adjunct to the other aspects of painting; in this section for beginners, it is not treated as a subject in its own right. The reason for this is the rigid grip that it can take on composition if not kept firmly for use as a tool. The question asked should not be 'where does the light fall and cause shadows?' but rather 'where does the composition need a dark area?' Only the most flagrant distortion is noticed, and then only if the composition is unsuccessful. In 81 the white cow shows little trace of shadow though standing further into the shade than its recumbent companion. On page 79 light has been artificially introduced behind Alice's head to prevent it becoming muddled with the window bars.

sketching in a garden or park

The first painting made out of doors is often on one's own doorstep and at first the possibilities of the view may seem hopelessly limited. Walk about. Plants and flowerheads seen close up and large in the foreground make an interesting contrast in scale with their fellows seen at a distance. Use a viewing-rectangle to get the effect. Repetition combined with decreasing scale can be very exciting—e.g. the diminishing row of trees overleaf. Try sitting as well as standing. The effect is to foreshorten any paths, and that can be a useful way to lead the eye into the picture. (De Wint must have been sitting on the path running along the stream.) Another way of leading the eye around the composition, passing from one point to another as in a game of basketball, is illustrated in Van Gogh's painting (56, 58a). Postage-stamp-sized diagrams of the composition of the paintings reproduced in this chapter appear opposite and show, with dotted lines, the path the spectator's eye is intended to follow. A lot can be learnt by doing the same sort of diagrams of the paintings in the colour section. They nearly all use some form of 'lead-in' from the foreground to the main subject.

One or two practical points are worth mentioning:

oil paint the main masses first, i.e. see a rosebush as a large dark shape; afterwards, decorate it with flowerheads—or paint holes between the branches; finish with the climax of light tones, as with the highlights on glass, page 67.

watercolour paint the light flowerheads first, and then bring the background up around them but still treating the plants in simple masses. If

need be, the light flowerheads, or spaces between the stems, can be scraped out gently afterwards with the corner of a razor-blade.

all mediums bear in mind the effect of distance on the colour of flowers; they will become less colourful as they get smaller and further away. Observation will confirm that though earth when held in the hand seems very dark and brown, a flowerbed is usually very light-toned unless it has been freshly watered. In the same way, the dark tarmac of paths has been dusted by footmarks to an equally light tone, rarely strong in colour. Go back to the comments on colour schemes earlier in this chapter; study Cézanne again and consider your plans for colour.

60 DE WINT Gloucester *crown copyright: Victoria and Albert Museum*

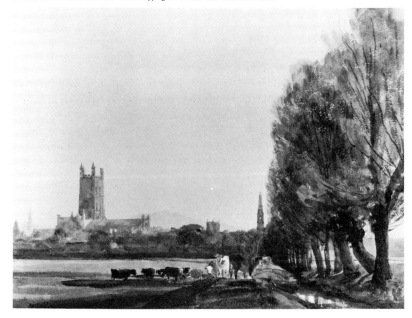

13 TEXTURE *use to show shape and form in trees*

Texture is often taken to mean an all-over pattern derived from the process of making a material or object, as in hand-made watercolour paper; but in a somewhat different sense it can be applied artificially to add interest to an otherwise plain surface, e.g. the cross-hatched penlines on the figures in Gordon Cullen's drawing (page 46) or simply to represent tone as in Tenniel's drawing overleaf. It can be two- or three-dimensional, flat or raised. It is another graphic tool—a means of rescue and camouflage or another pleasure, depending on the circumstances. It is certainly a source of much inspiration. Seemingly haphazard textures that come from the manner of working particular materials are exhilarating, such as the fragments of white sparkling through a watercolour wash caused by the bumpy surface of the paper (60), or a top-coat of oil-paint dragged over a differently coloured base (44). The key to the use of texture must be individual experiment. Those deliberately invented are exciting to look at, and personal to their creator. It could be said that each time the nature of a surface has consciously to be described, a graphic mark or shorthand symbol has to be devised. Gainsborough and his contemporaries evolved a particular kind of looped line for the texture of foliage (8). Since then a greater awareness of texture has produced draughtsmen such as Van Gogh (10) and Palmer (133), who have excelled in this field of pattern.

where and how to use it *(monochrome)*

light One of the most successful uses of texture is in combination with shadow, the converse of light. Applying an invented texture over the whole of a stone tower, for example, can become a chore. The problem of where to begin and finish the textured area can be solved by doing two things at once—defining the area of shadow, and describing the nature of the surface it is falling upon at one and the same time (35), thus avoiding self-conscious shapes of texture which are the sign of an amateur.

tone The contribution that texture can make to the tonal plan of a drawing is less obvious. Van Gogh's drawing (10) shows this clearly, however; penmarks produce different degrees of tone in given areas by conscious planning of their shape, size, pattern and relationship to one another. It conjures up a mental image which is almost coloured—the light tone of the dotted earth compared with the medium tone of the crop being harvested, or the rich full tone of the scrub and trees.

61 VUILLARD The Fireplace *National Gallery*
printed sideways—first reactions are to textures

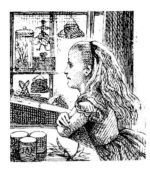

62 TENNIEL detail from illustration to
Alice through the Looking-Glass
crown copyright: Victoria and Albert Museum

distance Also shown in this drawing is the use of scale in texture to describe distance. The large heavy dark penstrokes of the foreground make an impression of close visible detail, whereas the small fine light strokes of the background indicate the decreasing scale and lightening tone values of the distance.

colour scheme and texture

The contrast of warm and cold colours was mentioned in the context of distance and space on page 43; this contrast can also be used effectively with texture. Often in the design of furnishing materials a light, warm, orange background vibrates beneath an overprinted or woven texture of dark, cool purplish-brown; or more unusually a cool battleship-grey contrasts with a warm, khaki-tinted grey of the same mid-tone, acquiring a richness which would be difficult to achieve in any other way. In painting, this is demonstrated in pointillist work such as Seurat's (91). By using textures within which colours are strongly contrasted—a dark one on a light ground or a light one on a dark—the tonal plan of a painting can be appreciably altered. Note Vuillard's tonal gradations by way of texture from the far end of the room alpine to the front. Thus texture and colour interlock, multiplying the possibilities to choose from. Most grassy slopes are not as rich in colour as those in Seurat's painting, nor do they necessarily have such vibrating shadows. The normal answer would be to use conventional 'grass-green' as the school-child knows it, producing a thoroughly dull colour scheme. This is why colour must be planned—in Seurat's case relying on texture to modify the colour optically rather than on colour-mixing on the palette.

trees—*shape and form by means of texture*
A horse-chestnut tree in flower offers almost the greatest challenge for organizing the use of texture. The first stage is to simplify its form mentally, and the principles of light and shadow explained in the diagrams

63 different kinds of tree, different silhouettes — sort them out before drawing
64 MINTON Corte Corsica *Tate Gallery*

65a 65b 65c

of cylinders (5) can help to suggest the dimension of depth—planning the total area in thirds, i.e. one-third shadow to two-thirds light or vice versa. Study the shadows on the topiary in Spencer's painting (57). Shadow is needed to give a tree such as a chestnut or sycamore three-dimensional form. Gainsborough's drawing (8) shows this clearly. The shadow will obviously vary according to the direction of the light, and will be different with different kinds of tree. Fundamentally, however, the principle is the same as that of the cylinder diagrams, with the shadow enlivened by the additional interest of texture invented in terms of the medium to represent the character of the foliage—cf. Palmer's cherry tree (43). Beware of irresponsible additions of chestnut flowerheads; equally spaced, they can give a very flattening effect, reminiscent of a currant bun. Individual strokes must be grouped in larger masses of texture, as in Minton's drawing opposite. Think of a tree as a mass or shape, not as individual leaves.

Within the total shape of a tree—that is, the full three-dimensional possibilities of 360°—individual limbs twist and turn; see note on page 21 about the junctions of branches. Winter trees have a sculptural quality: feel and enjoy the way in which they grow (183). It is useful when tackling problems of foreshortening to imagine that the branches are coiled wire springs (65c). In this way it is easier to understand what is happening; a similar approach is often adopted in drawings by sculptors such as Henry Moore (134).

Concern with form is often sufficient subject-matter in itself; the form may be emphasized by direction or movement (compare 90, 91). Trees begin with powerful thrusting growth upwards, out of the earth—the opposite of a child's cut-out toy tree which is placed from above upon some flat surface (65a, b). No matter how completely camouflaged the link with the earth is, perhaps by strong shadow cast from an overhead sun, it must be suggested, possibly by a network of roots or by the absence of any disruptive division between trunk and ground, as in de Wint's watercolour (60).

66

67 KONINCK Landscape with Hawking-party *National Gallery*

68

*66, 68 perspective diagrams
of painting above and
Constable's cloudscape, 89
respectively*

14 SPACE

Distance is involved whenever one is concerned with the difference in position between two points. In painting, 'distance' has come to mean the area of landscape furthest away. It is closely associated with the horizontal, because movement towards the 'distance' usually has to be made in imagination along the horizontal plane. It follows, therefore, that it has acquired two-dimensional associations within the sandwich of earth and sky. 'Space' on the other hand is associated with the third dimension as well—height, in addition to length and breadth.

At first reading, what follows will appear more than obvious, but almost every sentence has had to be repeated to students at some time, so even the most obvious remark is worth taking to heart.

Two fundamental ideas help to communicate a sense of space (70, 71). There are other ways, but these two principles should be remembered, if not always applied.

skyscapes

Skies are not a backdrop to a landscape like a stage set; they are the horizontal lid, flowing over our heads, roughly parallel to the surface of the earth on which we exist.

Imagine an overhead railway on a gigantic scale. Move away from it and watch a number of equally outsize carriages or containers moving along it. These are only your clouds and will be governed by the rules of the fan principle (24–27), particularly necessary if the 'railway' bends or curves (see opposite).

Alternatively, stand directly underneath and look along the aerial track; notice the lines of sleepers getting closer together as they close in on the horizon. Compare with the ridges of the banks of cloud in a sky where the clouds are drifting across the line of vision at right angles to it—that is, to the railway track of this mental picture (67, 71).

Knowledge of the four basic kinds of cloud is important for understanding the innumerable combinations and variations that can swirl up, change and vanish (72). As clouds can alter in an exceedingly short time, always work out some clear-cut idea of the kind of skyscape desired and its function in the design of the painting or drawing.

69a *'motorway' perspective in clouds*

70 the 'fan' principle of perspective
makes it possible to relate the vertical and horizontal dimensions of skies

69b *cirrus and cumulus clouds*

69c *nimbus or 'blanket' cloud breaking up into banks of stratus cloud*

71 the 'railway-sleeper' principle
a convenient term for a frontal view which shows effectively the decrease in scale of roughly equal distances or banks of cloud

69d *floating cumulus clouds*

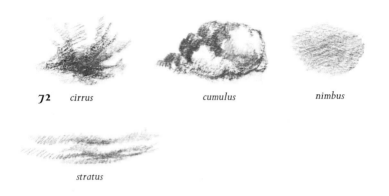

72 *cirrus* *cumulus* *nimbus*

stratus

Colour in skies calls for subtle colour-mixing, especially with the off-whites, and justifies exploring the range of manufactured blues besides ultramarine. These colours can be mixed, but the proportion of red and yellow added to achieve them is so infinitesimal when mixing small quantities that the advantage of buying them ready-made is obvious. Generally speaking, one is wary of giving specific instructions, as they discourage the development of a personal range of colour; it is useful to know, however, that as ultramarine is a purplish blue when seen alongside others, it requires a touch of brown to come near the full heavy colour of the sky of an August afternoon. Cobalt is a better all-purpose blue for skies. Cerulean blue, of a sort, can be obtained by adding viridian and ultramarine to white, but it is worth getting it in a tube; it has the breath of turquoise that skies outside hot climates seem to contain. Surprisingly, white plus the merest touch of viridian and alizarin crimson gives the most lovely, very pale steely-blue—a discovery attributed to the Impressionists.

waterscapes

For the purposes of this chapter these include sea or marine subjects, lakes, rivers and streams; fundamentally, they are all concerned with the same principle—that of water finding its own level and becoming flat. Having said this, it is fair to point out the paradox which exists in seascapes (figs. 73a, b, c overleaf). To suggest a global curve in the treatment of waves does give an enormously increased sense of space to a painting of the sea.

73a *global curve of sea's horizon*

73b *movement of waves* 73c *waves break when obstructed*

74 ALFRED WALLIS detail of seascape *Kettle's Yard Cambridge*

seascapes

It is a good idea, as others have recommended, to think of a wave not as a free object moving like a boat out at sea towards the shore, but as a log rolled along under a carpet, or as a relay race in which a chain of movement is passed on from one link to the next. Waves usually break only when they meet an obstruction such as rocks or cliffs.

There are two main approaches: first, there is that of a primitive painter such as Alfred Wallis, himself a Cornish seaman, who started painting only when he was seventy and whose work is totally intuitive; his ability to convey the smell and sparkle of sea-water comes from the way he uses paint and chooses colour. The other is the Romantic but none-

theless intellectual approach of Turner, in whose magnificent sea paintings the rules of perspective are clearly applied (93); however, they were merely tools, used to express Turner's firsthand experience, such as a night of storm during which he was lashed to the masthead. The sea has always been a subject of devotion and inspiration. For Homer, the Mediterranean was 'wine-like'. To other eyes the sea appears brown or green as well as blue, and luminous with glazes. The actual situation and occasion, the presence or absence of land, cliffs, hills, and, still more important, any atmospheric effects, will decide which colours will be reflected. The sea depends on all these factors for its colour. For marine subjects, almost more than any other, study of actual paintings is essential.

lakes, rivers and streams

When dealing with lakes, however large, the removal of the tidal element of waves completely alters the situation in all senses. Here the primary objective must be to show, by every available means, the flat plane of the water; incidental effects, such as reflections or the cats-paws of wind that ruffle the surface, are among the means for achieving this. Flatness is the prime difference between a rolling grassy meadow and a pond.

The human arm forms the radius of a circle. The line that it naturally draws is a section of this circle's circumference, and is not straight. To draw a flat line, conscious muscular control is necessary to pull the hand slightly towards one and counteract this natural curve, i.e. freely-drawn strokes producing an undulating surface (80). It is worth while stating the flat plane of a horizon or lake with a broken or lightly ruled line at the start. It will rapidly be integrated into the work, giving the flatness and emphasis needed.

Reference to the table-top diagrams (74) remind one of the need in sorting out the view-point; but now the table-top or lake will be seen from a three-quarter point of view, unless one is actually afloat, or the lake lies directly down one's line of vision (77a). With rivers particularly, the subconscious desire is to look down on the subject. This may in fact correspond with your viewpoint, but more often it does not (77b). The visual foreshortening of a ground-level view is sometimes hard to register and reproduce. It is impressively shown in Cotman's Yarmouth River (92). An improvement on the idea of a table-top when dealing with water is to imagine a horizontal piece of rectangular garden-trellis; this new mental image supplies a perspective grid for the lake or river's surface, upon which incidental manifestations of wind can be super-

75a

76 *waterfall*

75 BICCI DI LORENZO 15th C.
early Italian primitive painter
details from St Nicholas
rebuking the Tempest
Ashmolean Museum Oxford

75b

77a *aerial view of lake*

77b *shore view of lake*

77c *'potato' view*

77d *perspective grid*

78a cloud reflection — right *78b cloud reflection — wrong*

imposed, and the perspective angle of the level of the water lapping the shore can be judged. Note that the more foreshortened the view, the more accentuated the flat 'stepping' of the shoreline. Compare this with the curving potato shape (77c) that the beginner usually makes from this viewpoint when drawing what he thinks he sees, without actually looking. It is sometimes useful to pencil this grid in lightly so that it acts as a perspective reference throughout; its sense remains even after the grid itself is obliterated or removed. It gives a framework on which to float shapes or patterns of movement, and, though they may be far from rectangular, they will help to underline the flatness of the water (77d).

Streams, at first sight, seem to disguise all evidence of this flatness as they tumble over waterfalls and rocks (see 76). Even the most turbulent, if examined carefully, has calm pools protected from the current by a boulder, where the water shows its real character by lapping horizontally.

water patterns

The movement of wind or boats on water is impossible to chart accurately even if one wished to do so. Detail of texture is decided by nature in the forms water takes, by the painter in paint (75b). The pattern of movement in water is rhythmic and repetitive, and must be studied carefully; a secondhand formula tends to be stereotyped. There is also scope for the use of scale to describe distance, by emphasizing the decrease in size of the waves or ripples as they get further away.

reflections

These can be visual brain-teasers, like shadows, if taken too seriously; but care should be taken to make the reflection of a Lombardy poplar, for example, plummet vertically downwards without a suspicion of a sideways step or slant; the depth to which it should plunge is shorter than might be expected (78). More intriguing is the realization that the reflection of a cloud, to be truly accurate, comes from a slightly different viewpoint than the observer's — what the water sees is the bottom of the cloud. Choice of colour for reflections in water is governed

79 *structural plan of cliffs*

80 *idle scribbling*

81 GIRTIN Rocking Stone *Tate Gallery*

by the filter principle described on page 67, remembering that there are fewer highlights and the reflection is more close-toned—the lights less light and the darks less dark.

landscapes

The term 'landscape' can refer to any view—of countryside, town, sky, or even of sea. Here it is used in the limited sense of countryside, whether grandly panoramic or local and intimate. It comes last, because the lines of the earth's perspective, for those interested in this approach, are often less obvious beneath the camouflage of past upheaval and erosion, vegetation and human intervention. All the points made about skies and water necessarily apply to a landscape. What seems to require more emphasis is the need to sort out the fundamental design of the view— the rhythm and movement of the hills and the plains, and the balance of the main tonal masses of the subject. Girtin's painting is soundly constructed, and deliberately enlivened by a figure and cows. The rhythmic equivalent of the effect of tidal waves might well be seen in landscape in the stratification of the hillside and the related excitement of the changing shapes of trees, boulders and rocks (64, 81, 89). A plan made along these lines before starting a subject can produce some order in what otherwise might be irrational muddle: work out a structural pattern for the whole, before drawing in details (79). River-banks also show stratification in miniature, where they have been worn away. Rocks and boulders should be thought of as fashioned out of the landscape rather than added to it. Carried along by the floods they are generally rounded, whereas rocks newly split from a cliff face will be sharp-edged. Stones and pebbles vary in size, and this kind of contrast can be exaggerated to give a sense of distance, particularly if there is a relationship in shape; such relationships help to give unity to a jumbled subject. Notice and emphasize how stone walls are made (115). As with trees, work on the simplest of plans for light and shade. Avoid having to fill in large areas of detail unless it proves enjoyable—detailed treatment must always be based on careful observation, not spoilt by idle or mechanical scribbling (80). On page 73 the importance of placing the horizon was stressed—the main pitfall in designing a landscape. Give thought to the purpose of the foreground in the composition. Do not allow it more space and detail than it merits. Concentrate on the main part of the composition—photography automatically achieves this by its limited range of focus, blurring the unimportant areas which it cannot treat with equal attention.

82 MATTHEW SMITH
Peonies
Tate Gallery

83 BRIDGET RILEY
Fragments
Tate Gallery

15 WHAT KIND OF SUBJECT?

indoors *still-life, flower painting, figures, portraits, animal drawing, imaginative compositions, illustration, design, work from landscape sketches*
outdoors *'plein air' landscape (landscape painted on the spot), working drawings and colour notes for later indoor studio painting*

still-life forms the bulk of most beginners' subject-matter. The idea or intention of a painting is what makes it worth while; still-life can offer just as much opportunity to explore colour, form and design as the most exotic landscape.

flower painting is often regarded as a category peculiar to itself. This produces undesirable results where whimsy and secondhand ideas interpose themselves between the painter and the subject. For beginners it is better to regard flowers as a still-life subject in which rhythm and movement are all-important.

figure drawing, animal subjects and portraiture require models, but these do not have to be in the studio. Use a pocket sketch-book in odd moments and do not be put off too easily.

imaginative subjects are mostly based on past experience, consciously or not. Such subjects as the seasons, or the course of a river from its source down to the sea, can provide a stimulating theme round which to work.

illustration see page 157.

design-oriented work is more concerned with abstract ideas derived from a chosen subject than with direct representation. Indeed all subjects need planning or designing in these terms—the degree of abstraction or realism is for the individual to decide. Students are often unaware of their own design potential. Do not make the mistake of supposing that the principles outlined in Chapter 25 are irrelevant to everyday painting.

working drawings are made specifically for later use, and are the better for having a clear-cut purpose. They give the landscape-painter freedom to work as he chooses, serving as a middle stage in which irrelevancies are filtered out.

landscape painting should be the result of deliberate choice, just as much as any other subject. A good landscape painting is more than just a record; it is a statement about one particular piece of spatial experience.

84 DAUMIER detail from The Blue Stockings *British Museum*
'litho' techniques evident in use of chalk, and scraping out of white lines

85 CONSTABLE Stoke-by-Nayland *Tate Gallery*
traces of dark 'ground' can be seen throughout

SKETCHING EQUIPMENT

Materials and methods for drawing and painting have been discussed under their separate categories, and individual preferences should now be clear. The following list includes some extra equipment which may prove useful for outdoor sketching:

folding easel plus removable 'arms' for a paint-box shelf (useful ballast). An easel is not so essential for watercolourists, who may need to alter the angle of work to something flatter for the occasional wash; but even with watercolour it is essential to be able to prop work up vertically at times, so as to view it from a distance.

folding stool or chair: reasonable comfort is worth while; do not rely on finding a low wall in the right place.

oil-paint box: this may incorporate an easel arrangement in the lid, but it is unlikely to be stable and can only hold small-sized canvases.

oil-paint plus turps, oil and rag—see Chapters 16 and 17.

two canvases or boards the same size, one for actual painting. (see below)

canvas-pins pointed on both sides, so that two surfaces can be pegged together face to face, for carrying without touching—sold at good art shops.

brush-box: essential for watercolour brushes, safeguarding their points; some boxes can be hung from an easel, and will help to steady it.

watercolour-box preferably with a thumb-ring for holding, somewhat like a palette; should have a removable bar so that individual pans can be removed or replaced. Whole pans give more generous mixing conditions than half-pans. Tubes are another possibility, though there is a tendency for colour squeezed out to harden quickly in a way that pans of artists'-quality paint do not.

paint-pot, rag etc. (page 25).

extra water jars—one for rinsing brushes, one for clean water.

watercolour paper with board and clips or sticky tape, or stretched paper (page 23).

other extras: sunglasses may be necessary for a time, if working into the sun or if the glare from white paper or the ground is worrying. Sometimes it is not possible to angle the board so that it is in shadow. A sunhat or beach-umbrella is better when working in colour. In cold weather, use mittens—cut fingertips off woollen gloves.

PIGMENT LIST

Pigment names for gouache are similar to those listed below bearing in mind the absence of transparency. The different mediums are indicated typographically. In 86 start with pigment on left, gradually add more blue by stages until pure ultramarine is reached. Repeat for 'shadow' row beneath, each time adding a little white as well.

Whites OIL-PAINT titanium—useful for underpainting, flake—good covering power, zinc—semi-opaque; *acrylic-polymer* titanium; WATERCOLOUR Chinese white (zinc)—keep for emergencies as it can cause a transparent wash to become opaque and muddy.

Yellows/bitter† OIL-PAINT *acrylic-polymer* cadmium yellow pale or light; WATERCOLOUR cobalt yellow.

Yellows/warm OIL-PAINT Naples—creamy, useful for flesh tints; OIL-PAINT *acrylic-polymer* WATERCOLOUR cadmium yellow, yellow ochre (opaque) and raw sienna (transparent)

Reds OIL-PAINT *acrylic-polymer* WATERCOLOUR burnt sienna, light red, cadmium red, alizarin crimson; OIL-PAINT WATERCOLOUR Venetian red (similar to light red) Indian red; WATERCOLOUR crimson lake (similar to alizarin crimson)

Browns OIL-PAINT *acrylic-polymer* WATERCOLOUR burnt and raw umber, Van Dyck; WATERCOLOUR warm sepia (non-granular)

Blues OIL-PAINT *acrylic-polymer* WATERCOLOUR cobalt, cerulean, ultramarine*; OIL-PAINT WATERCOLOUR Prussian, pthalocyanine; *acrylic-polymer* pthalo; WATERCOLOUR Antwerp

Violets OIL-PAINT WATERCOLOUR cobalt violet; *acrylic-polymer* violet, magenta—rarely needed but cannot be mixed (e.g. for some flowers)

Greens OIL-PAINT WATERCOLOUR viridian; OIL-PAINT terre verte; *acrylic-polymer* pthalo, olive

Grey WATERCOLOUR Payne's—valued highly by many water colourists; ultramarine, black and yellow ochre produce a similar mixture.

Blacks OIL-PAINT WATERCOLOUR ivory, lamp; *acrylic-polymer* Mars. Black not included before as use inhibits experiment with different ways of darkening a colour; colour-mixing based in this way is readily identified; with yellow it provides an exciting range of greens.

* Ultramarine appears too purple-tinged to be regarded as a primary colour for the spectrum but it is a fundamental colour in that it cannot be mixed. The addition of white in lighter tints appears to balance this purple bias.
† Lemon and primrose are vague terms—they may include white.

Interesting mixtures in oil colour
Prussian blue and yellow ochre with flake white
Alizarin crimson, Light red and/or Indian red, Ivory black and flake white
Alizarin crimson and burnt sienna; Ivory black and Indian red
Impressionists' sky recipe: white with a touch of alizarin crimson and viridian
Suggested mixtures for watercolour are given on page 1 2o

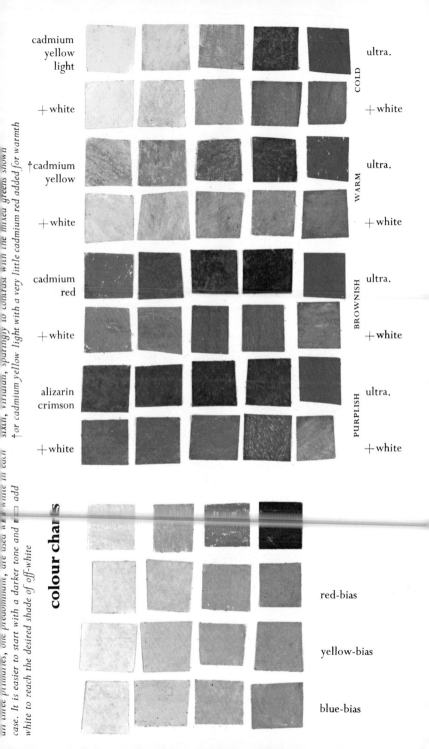

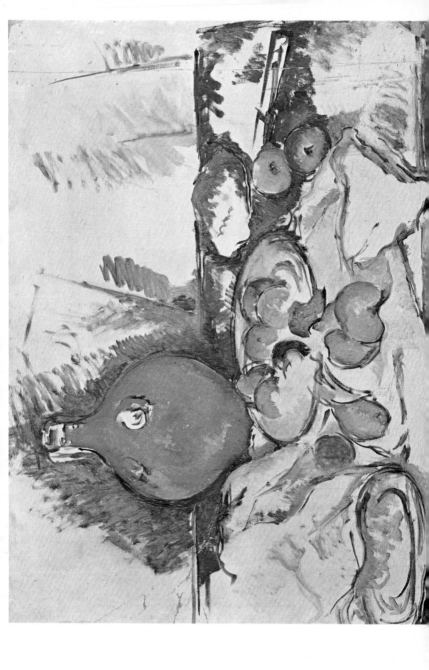

88 CEZANNE Still-life with Water-jug *Tate Gallery, Lond*

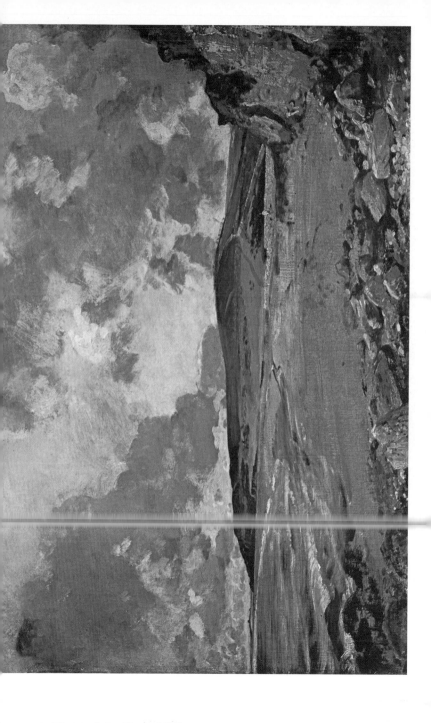

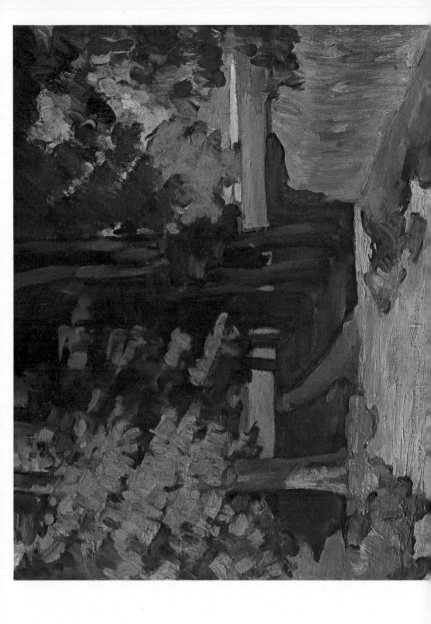

90 CEZANNE Avenue des Grandes Arbres au Jas de Bouffan *Tate Gallery*, *Lon*

92 COTMAN View of Yarmouth River *British Muse*

TURNER Yarmouth Roads *Lady Lever Gallery, Port Sunlight, Liverpool*

94 DERAIN Collioure *Scottish National Gallery of Modern*

95 RENOIR The Gust of Wind *Fitzwilliam Museum, Cambri*

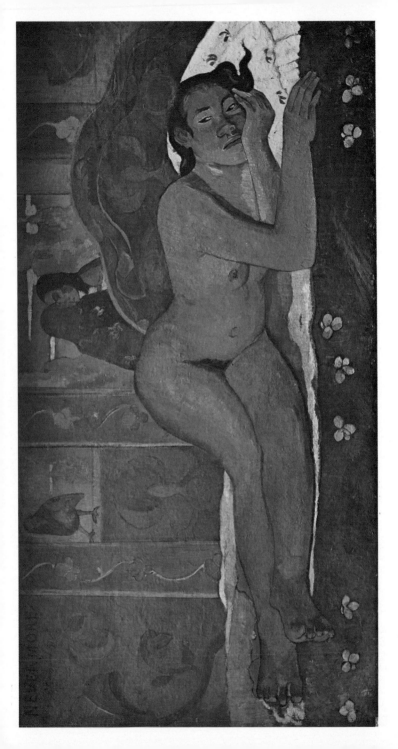

GAUGUIN Nevermore *Courtauld Galleries, London*

DEGAS Woman at her Toilet *Tate Gallery, London*

98 ROMNEY Emma, Lady Hamilton *National Portrait Gal*

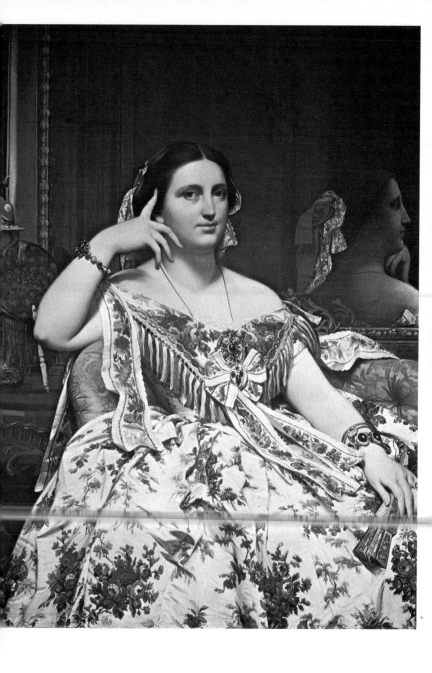

INGRES Mme. Moitessier seated *National Gallery*

I MONDRIAN Composition in Red, Yellow and Blue *Tate Gallery*, *London*
right: Harry Holtzman

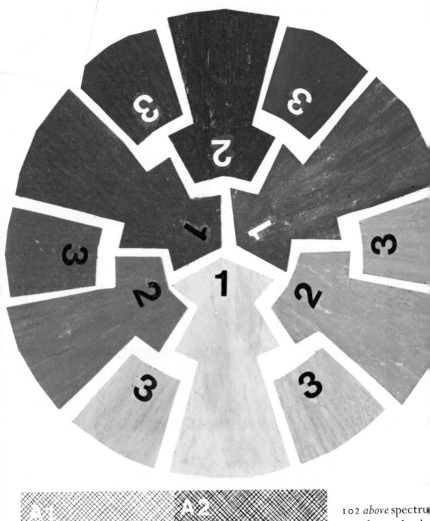

See top of page 11

102 *above* spectrum or colour-wheel

A sizes for paper

A1 $23\frac{1}{2} \times 33\frac{1}{8}$ *ins*
A2 $16\frac{1}{2} \times 23\frac{3}{8}$ *ins*
A3 $11\frac{3}{4} \times 16\frac{1}{2}$ *ins*
A4 $8\frac{1}{4} \times 11\frac{3}{4}$ *ins*

other paper sizes

Royal 20×25 *ins*
Imperial 22×30 *ins*
Dble Elephant 27×40
Antique 31×53 *ins*
Dble Crown $20\frac{1}{2} \times 30\frac{1}{2}$

opposite THE SPECTRUM OR COLOUR-WHEEL
1 the primary colours form the basis of the spectrum
yellow—light toned; red—medium toned; blue—dark toned
2 the secondary colours are obtained by mixing two primaries
orange = yellow+red; green = yellow+blue; purple = red+blue
3 tertiary colours are a mixture of one primary with an adjacent secondary

16 EQUIPMENT AND MATERIALS
studio furniture; painting surfaces, paper, board, canvas; stretching canvas; priming; mediums; varnishes

studio equipment

For work in colour, daylight is desirable. Unlike drawing, a change in the middle of a painting from daylight to artificial light can be disastrous. Tungsten, that is ordinary electric light, has less of a draining effect on colour than strip-lighting.

Always arrange your work so that light falls directly upon it, preferably from the left, if a righthanded painter, because of the shadow; do not stand with your back to the light but sideways on. Necessarily avoid having to paint looking over your shoulder, i.e. facing and painting in one direction the view or subject that is in another. A near upright angle of support is best for work that is later to be displayed at a distance upon a wall. With any painting, especially if much larger than $2 \times 1\frac{1}{2}$ ft, step back at intervals to view your work from a suitable distance. A near-horizontal surface is needed for work to be seen at close range such as illustration, lettering and some design work.

folding-easel for outdoor sketching
studio-easel holds large paintings firmly without rocking
high-stool for use with easel if necessary
'donkey' a combined stool and drawing-board support, awkward for viewing work at a distance
designer's easel hinged in the middle to allow alternative use with a drawing-board as a drawing-desk
large portfolio for transporting or storing drawings
rack usually purpose-built for storing paintings
table, cupboard
for model small raised dais or 'throne'; attractive and reasonably comfortable chair or sofa; extra portable heater(s)

painting surfaces or supports

PAPER ordinary paper, as opposed to artists', comes in A sizes; handmade paper is manufactured in different sizes which are only approx. (p. 112).
bank thin, white and very smooth; suitable for pen and pencil
bond slightly thicker; otherwise similar to bank
cartridge less smooth, off-white and thicker, for all general purposes—must be stretched for watercolour
hot-pressed very smooth and white; for pen, pencil and acrylic-polymer paint; less suitable for watercolour
not-pressed or cold-pressed open, coarser weave; possible for water-colour
pasteboard or cardboard for acrylic-polymer; permanency not guaranteed
Ingres paper (named after painter)—grained and ideal for pastel etc.
sugar-paper—cheap, very absorbent; for powder or poster colour
ricepaper (Chinese or Japanese paper)—very absorbent, attractive for prints; must be sized for watercolour (see page 116, how to size surfaces)
watercolour-paper—the thickness is important:
Paper is graded by the weight of a ream, that is approximately 500 sheets. 72 lb lighter weight papers will do for watercolour if stretched; 90 lb is the intermediate weight; 140 lbs is fairly heavy, the minimum weight for all-round use. The best kinds are as heavy as 250 to 400 lbs, like a thin handmade board. They are not so very extravagant, as the reverse side can usually be used if the first attempt is a disaster; they can also be put in a bath of cold water and wiped practically clean. Machine-made paper is cheaper, but may have a monotonous grain; handmade is desirable though expensive.

A medium-coarse grain is most popular as it allows white patches to sparkle through a wash; the choice of grain is a matter of personal preference. Watercolour papers are marketed under various trade-names which are liable to change in availability. In general the use of cheap, inferior paper is taken to indicate a lack of professional ability and stature.

The kind of paper must be carefully chosen for the drawing medium being used; paper and medium contribute equally to the quality of the work.

hardboard is entirely suitable for painting. It is sold in various thicknesses: $\frac{1}{8}$ in. is satisfactory; $\frac{1}{10}$ in. is a little thin; $\frac{3}{16}$ in. and upwards is unnecessarily heavy. Hardboard panels larger than 2×3 ft must have an interlocking framework of wood glued to the back to prevent warping. 1 in. \times $1\frac{1}{2}$ in. strips round the edge also serve to give depth to unframed paintings, but they should have horizontal and vertical battens fitted

between them. Ideally this basic carpentry should be done before the painting is started. Hardboard is absolutely smooth on one side and imprinted with a screen texture on the other, not unlike a mechanical version of some coarse woven material. Experiment with both sides.

plasterboard and other builders' materials are unreliable and unsuitable, though asbestos board is possible for mural painting.

Boards made of paper waste and wood pulp are too brittle as they are really only heavy cardboard.

wood—contrary to popular opinion, plywood is less likely to warp, and is therefore more satisfactory for painting than solid one-piece panels retrieved from old panelling or furniture. 5-ply ($\frac{3}{16}$ in.) or slightly thicker weight should be used, but in general it is not as satisfactory a support for paintings as hardboard. Wood panels can be primed for use with either acrylic-polymer or oil-paint (page 117).

other surfaces more usually associated with mural or decorative work are glass, metal and plaster. The first two present the same problem of extremely poor adhesion. If they have to be used, the surface must be well-roughened and a white lead priming applied before use; they are materials clearly better suited to engraving than to painting. Plaster, however, is a surface traditionally enjoyed by painters practising a fresco technique based on watercolour. This involves a high degree of craftsmanship. Plaster can nowadays be painted with acrylic-polymer colours, which take well, and, being waterproof when dry, are ideally suited for the purpose.

canvas-board—pasteboard to which prepared cloth has been stuck down. Only relatively satisfactory as its permanency is questionable.

canvas—white cotton canvas such as duck, sailcloth and twill are cheap but not as good as natural-coloured linen with its distinctive weave. Mixtures of linen and cotton are undesirable because of their unequal properties. Jute or hessian become too brittle. Because it is cheap, cotton canvas is also likely to have an indifferent priming if bought ready-primed. Unprimed canvas is slightly cheaper, and if you have time and space it is much more fun to stretch and prime it yourself, experimenting with colour and texture of grounds. Different primings are available for acrylic-polymer and oil paintings.

how to stretch a canvas

First assemble the bevelled wooden stretcher pieces which interlock, and are sold in a wide range of lengths. The stretcher pieces must all be of the same width. Tap them together with a piece of wood so as not to

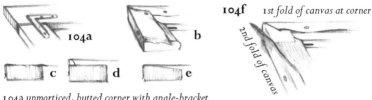

104f *1st fold of canvas at corner*

2nd fold of canvas

104a unmorticed, butted corner with angle-bracket
104b morticed corner of bevelled stretcher pieces with neatly folded corner
104c canvas dragging over inner edge of unbevelled frame
104d canvas stretched over quadrant section, glued to unbevelled frame
104e canvas stretched across bevelled frame
104f double 'Nurse's Corner' folds

dent the frame, and check for squareness by fitting them into a corner of a doorjamb. If correctly fitted the diagonal measurements will be the same. Put the canvas face down; place the frame on top, checking that it is parallel with the grain, and cut the canvas at least $1\frac{1}{2}$ in. (3·8 cms), larger in size all round. Without allowing the frame to slip, raise the canvas and frame to an upright position and tack down in the middle of one of the shorter sides. Turn the frame round and, pulling the canvas firmly with an even strain, tack it down in the middle of the other shorter side and then in the middle of both the longer sides. Check again that the corners are square before tacking down at the corners and at approximately 4 in. intervals right round. Neaten the canvas at the corners (104) using a 'nurse's corner' fold as in bed-making, but on both sides, and fasten down with a tack as near the corner joint as possible. Finally tack down the loose canvas at the back of the frame. Wooden wedges should be inserted in the slots at the corners, so that by hammering them home at a later stage joints can be forced slightly apart and any slack in the canvas taken up

Crude systems of canvas stretching are unsuitable for anything but practice work. For this a frame can be knocked up out of plain, unmorticed lengths of wood fixed to corner triangles of hardboard or to angle brackets, 104a. If the wood is not bevelled on the inner edge, it is better to glue a thin ridge of wood, quadrant in section, round the outer edges to lift the canvas from the inner edges of the frame (104d).

sizing and priming a canvas for oil-paint

The stretched surface should be brushed over with a thin coat of 'size' so that the pores of the canvas are filled and sealed. It is essential that oil-paint should not come into contact with the fibres, otherwise the canvas will rot. Size, a crystallised form of glue, can be bought in various

strengths at hardware shops; it should be dissolved according to its instructions—usually about $1\frac{1}{2}$ oz to a quart of water. The sized canvas must be primed, that is, given a first coat of paint before use. Either this can be made by mixing 1 lb of white lead in oil (ordinary decorators' undercoat) into 3 fluid oz of turps, or a commercially produced primer can be bought. Brush well into the weave of the canvas in all directions, and finish with long strokes in line with the canvas weave to disguise the brushmarks. When dry, apply a similar second coat. If additional tooth or coarseness is required, pumice powder may be added to the first coat.

priming a canvas for acrylic-polymer paint
Seal the surface with acrylic-polymer medium diluted with water before coating it with acrylic-polymer primer. Emulsion paint is sometimes used by students, but any areas of the white ground left uncovered will discolour; bitter experience proves that the chemicals added to house-painting brands make them unsuitable for artist's use.

priming hardboard and wood panels
It is safer to prime wood panels, or to seal them with acrylic-polymer medium diluted with water, before priming. The same methods of sizing and priming for oil, and sealing and priming for acrylic-polymer paint, are as suitable for hardboard as for canvas.

alternative methods of preparing hardboard for painting
in oil or acrylic-polymer paint

The smooth side can be covered with thin muslin at the same time as sizing and sealing; it gives a pleasantly irregular texture to work on. If the textured side of the hardboard seems too mechanical in grain, the following method of modifying or filling it, when preparing it for painting, can be used. *1st stage* mix whiting and size to a consistency of fairly thick cream; brush on, allowing it partially to fill the grain and break the oppressive regularity of the mechanical texture. *2nd stage* when dry, cover lightly with a coat of clear size, brushing in one direction only. *3rd stage* brush a second coat of clear size on, in opposite direction. *4th stage* finish with primer in normal way.

n.b. acrylic-polymer paint can be used on canvas or hardboard prepared for oil-painting, but the surface of the support should be roughened with sandpaper to increase adhesion. Canvas or primer prepared specifically for acrylic-polymer is better. Such canvas is unsuitable for oil-paint, but the primer can be used on wood for oil-paint.

coloured imprimatura grounds

'Ground' is the term used to describe the surface to be painted (see 89, 94 for examples of coloured grounds).

Transparent coloured grounds are achieved by mixing the required colour with size for oil-grounds, and with water or medium for acrylic-polymer grounds. If the primer is an acrylic-polymer one, the surface should be dampened with water first. The ground can be applied before or after sketching in the subject, and can thus be used to fix the drawing.

opaque grounds are made by mixing colour into the second coat of primer; traditional colours are terra-cotta, pink, dull green and grey.

coloured pastel-paper can be bought in great variety but a watercolour wash can be painted over suitable paper; the wash should be opaque as the individual quality of transparent watercolour could be distracting.

medium

In this context the medium is the liquid with which the paint is made and afterwards can be diluted.

for oil-paint

raw linseed oil—not an artist's material; rich, gold and treacly.

cold-pressed oil—linseed-oil partially refined.

refined linseed-oil—commonly used for oil-painting; pale, off-white.

stand-oil—linseed-oil further refined; much heavier, can be thinned with turps to a painting consistency; very useful for glazing.

poppy-oil—brighter and clearer than linseed-oil with less tendency to turn yellow; its slow drying-rate, and the possibility of its cracking with age, make it inferior to linseed-oil.

turps (turpentine or turps substitute i.e. white spirit) see page 57.

for acrylic-polymer paint

Water and the acrylic-polymer medium, the emulsion of oil and water used in the manufacture of the paint, page 51; the medium on its own can be used as a glaze or varnish.

patent mediums and gels *for glazing or impasto work*

The 'bulking out' of paint is a common practice in this century. It is sometimes called 'extending' paint, but this can also mean spreading it very thinly e.g. over a white ground to get the maximum brilliance of hue. Theoretically it is undesirable to add filling ingredients such as sand for textural purposes. The structure of the paint is impaired; its powers of adhesion are doubtful, and there may be flaking, cracking and pulling away from the ground; future cleaning of the paint surface is

extremely awkward. Various gels and mediums have been produced which allow relief or impasto work to be carried out economically and safely. Some of these are intended for glazing purposes, allowing greater ease in use and speed in drying, compared with oil.

acrylic-polymer gel/medium makes impasto work possible and also retards the drying-rate, which gives acrylic-polymer painting greater flexibility.

retarding medium in polythene spray containers increases the ease with which acrylic-polymer colours blend by delaying the rate of drying, and is useful when working outdoors.

modelling-paste has good adhesion and makes thicker impasto or three-dimensional effects possible.

varnishes

retouching varnish is very light and can be used if desired on small areas during the course of a painting; its effects are not necessarily permanent.

damar varnish is usually considered the most satisfactory; only the thinnest of films should be used, and it should be brushed out well in all directions. Thick layers of varnish can be the cause of later damage to the paint surface and they tend to make it look like polished linoleum.

mastic varnish is less permanent than damar, with a tendency to turn yellow.

acrylic varnish has a duller finish than damar; it dries faster but is less easy to use if more than one coat is used.

fixative page 128 *brushes* pages 53, 56 *pigments* page 96

17 COLOUR: MEDIUMS AND TECHNIQUES

The names of pigments on page 96 include recommended additions to the basic six colours needed, though it is by no means necessary to acquire and use them all. Some colours not mentioned are occasionally available, but they are not advisable because of their lack of permanency or for other reasons. Always buy colours with proper pigment names, and avoid vague or fancy descriptions such as 'light green' or 'primrose'; the only exception to this rule is 'light red'. In acrylic-polymer and watercolour it may sometimes be necessary to buy a clear yellow under the unsatisfactory name of 'lemon yellow'. Gels, mediums and retarders have already been described on page 118; only experiment can prove their use to the individual.

positive and negative approaches Many effects associated with oil-paint are common to the acrylic-polymer medium, such as the deliberate modulation of a colour, page 71, flat and impasto surfaces, and what could be described, paradoxically, as a positive and negative technique.

105a *'positive' painted lines* 105b *'negative' painted lines*

In 50c the negative shapes of the background left by the spoon were
seen to be as important as the positive shape of the spoon itself. Morandi's
painting showed this approach clearly (52). Branches of trees or win-
dow bars often require far finer lines than it is comfortable to attempt
with even a small paint-brush. The struggle to produce something
sufficiently delicate can often produce a laboured, tight feel. If the line
in question is painted firmly, though seemingly heavily, with thinnish
oil paint (105a) it can be reduced to the required width by painting in the
background shapes on either side to overlap it (105b), thus leaving a
fraction of the original brushstroke visible. This can obviously be done
with light strokes overlapped by dark backgrounds or vice versa. In both
situations if the original paint was not too rich with oil, or applied too
thickly, it is possible almost immediately to add thicker paint on top.
The line or shape being treated in this way becomes part of the under-
painting, firmly integrated into the paint surface in fact, and so into the
painting, rather than remaining seated as a dark lump on the lighter sky,
refusing to recede correctly into the distance (cf. church tower, 85).
To be effective, the overpainting must be opaque, which, of course,
rules it out for watercolour purposes. It is one way of painting a straight line.
transparent or opaque colour This, surprisingly, is a contrast that can be used
in all three mediums. With pure watercolour, you need to know the
individual qualities of colours, e.g. the clarity of raw sienna against the
chalkiness of yellow ochre. For this purpose the following experiments
in watercolour are worth trying; as well as straight mixtures, try a
brushstroke of each colour over the other when dry: alizarin crimson
(transparent) and viridian; cadmium red (opaque) and viridian plus
yellows; oranges (of raw sienna, yellow ochre) and blues (cerulean,
ultramarine); greens from burnt umber and Winsor blue or yellow and
black; violets (alizarin crimson and ultramarine) and different yellows;
Winsor or cadmium yellow each with Payne's grey.

In a landscape where the foreground and distant trees look muddled by being the same tone, they can be distinguished by using clear, brilliant colour for the nearer trees and an opaque version *in the same tone* for the distant ones. The same principle applies with oil-paint—for transparent colour, use the pigment spread thinly, strongly diluted with turps as a stain, or with oil as a glaze; for the opaque version, add white. Similar effects are possible with acrylic-polymer, using water or the medium.

Pointed and square-tipped brushes and painting-knives being the traditional tools for painting, aim to build up a collection big enough to allow a couple of brushes for use in the general area of each primary colour; i.e. at any one moment a painter may be holding as many as six brushes or he may stand them in a jar beside him. The more brushes available, the less often a brush has to be cleaned for a fresh colour. Usually the colour already in a brush can serve as the necessary addition to a new mixture, but only if it is to be a muted shade. Beware of white; it can creep perniciously about the palette. Clear colours need a clean mixing area, clean brushes and organized reservoirs of paint, see page 6. Clear colours in watercolour require the same amount of discipline, in this case the frequent refilling of a waterpot with clean water. Besides these techniques and other methods described in the following sections on the various kinds of paint, further information is given on page 96.

watercolour techniques

The following list of equipment is designed for those wishing to take up watercolour painting seriously: artists' quality watercolour paints in whole or half-pans or tubes; watercolour paper plus tester area (margin or piece of odd paper); rag, blotting-paper and sponge (for lifting or lightening colour, adding texture or wiping brushes dry); two water pots (one for clean water, one for rinsing brushes); palette or saucer (allows well of water to collect in centre and leaves a dry 'bank' for colour-mixing); three watercolour brushes, nos. 12, 8 and 4 approx.; board with clips or tape and good paper.

The quality of paper has been stressed as important, particularly in watercolour painting. A heavy-quality paper, with deckled edges, is such a good-looking thing in its own right that, if working large, there is every reason to continue right up to the edge, and later to float it on a mount (page 200). However it is more usual to let the watercolour make its own unruled edge and to give it a margin of breathing space all round in lieu of a mount; on the other hand do not allow it to

106a *dry-brush effects by dragging — brush held sideways*

become a weakly decorative vignette. Watercolours may not cost much in materials compared with oil-paint but, to look good, it is essential that they should be properly framed and displayed. The schools of thought on how to paint in watercolour are legion. The individual must decide for himself. The principles of colour are discussed later, but at this point it is right to mention the idea of a flat, tinted all-over wash. For a 'sunny scene' it is sometimes suggested that such a pale gold wash is an asset. It can be, but it also removes the brilliance of white from the top of the tonal scale; and the result may be a desirable warm harmony, but it may also be a dull butteriness. Do not use pat recipes without some thought. To many, the evidence of a white ground is essential to the transparency of watercolour.

The practice of working on two watercolours at once can be highly beneficial — besides allowing experiment in the use of different grounds. There is always a moment of delay, waiting for a wash to dry before the next stage can be put in, with the ever-present temptation of not waiting long enough. Working simultaneously on two watercolours should prevent this happening, and will allow the benefit of experience gained in the first painting to be put to use immediately in the second.

how to put on a flat wash if needed

Mix as much paint as you think necessary, then double it in quantity. Once you start you cannot stop to mix more. Prop the surface up just off the horizontal; fully load the largest brush available with paint. Starting at the top left corner, assuming you are right-handed, and working towards the right, apply the paint with wet flat strokes in horizontal bands. If the brush has to be refilled before the end of the band, make sure that each stroke catches up and blends with its predecessor. The next band should go on before the bottom edge of the first band has had a chance to dry. The paint will drain gently to the bottom of each band and should be absorbed smoothly into the next. Do not rinse the brush out until the wash is completed — if necessary, wipe or shake the brush dry. Extra water will only dilute the colour

106b *avoid the stabbing action of a writing position*
weight placed on the brush-head (the hand may rest on the little finger)—besides washes, brush marks can vary from delicate lines to heavy stippled dots

unevenly. The saucer of paint should be stirred each time the brush is reloaded to prevent sediment collecting. Any blemishes must be accepted; it is not possible to touch up a wash. The secret of success is to work fast and smoothly.

For work requiring a really dense, flat background of colour, it may be better to work on a manufactured coloured paper, thus avoiding any problems of the ground lifting. Tinted or coloured paper usually needs stretching for watercolour.

mixing watercolour

It is helpful to think of watercolour in roughly three consistencies:

a lot of water and a little paint—a pale tint (maximum contrast of tone with that of original pan of colour)

one-third paint and two-thirds water—a positive coloured wash (nearer the tone-value of the pan of colour)

paint mixed with the minimum of water—suitable for brush drawing or dry-brush work (almost the same tone as the pan of colour)

The various consistencies of watercolour paint should be thought out and used consciously. Always knock the excess water out of a brush by tapping it on the water-pot lip before mixing paint, and so avoid flooding the pan of watercolour. The use of an odd bit of paper to test out colours and tones is essential and should become automatic.

exploiting the medium

To work towards a natural and personal manner of using the medium should be the goal of any painter; firsthand experiment is the only way to get to know its limitations and strengths. The following exercises taken from the technique of aquarelle are one way of doing this, and have been used to achieve the cloud effects in 41.

different dampnesses of paper

1 With clean water on the brush, dampen an envelope-sized rectangle of paper.

2 When very wet, put a brushstroke of strongly-mixed blue paint across it and watch the colour run—likely to look like clouds.

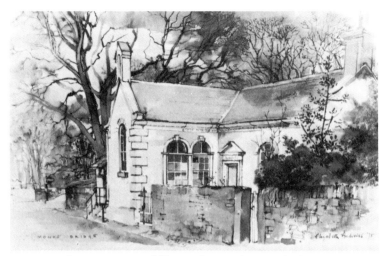

107 AUTHOR'S SKETCH *textures of foliage and stonework act as a foil for each other*

108 *these muddled tones and repetitive textures would nowadays be recorded less fussily by a colour photograph*

3 Do the same with the other two primaries, red and yellow, each on their own separate rectangles.

4 Return to the first rectangle when half-dry and add a second brush-stroke of blue; notice how the colour runs less and becomes more positive in tone. Repeat this effect on the red and yellow versions.

5 Return to the first again and add a blue brushstroke when the surface is practically dry; the brushstroke of paint hardly runs at all. Again repeat this with the other colours. Note how much harder it is to achieve any effect with the lighter-toned yellow primary.

6 Dampen a larger rectangle and repeat all this with the three primaries together, the blue brushstrokes in one corner, the red in another, etc., gradually allowing them to overlap and mix in the middle. Study the results, working further colour in how and where you please.

7 On a semi-dry blue wash, drop a globule of strongly mixed yellow paint; it will shift the blue paint. Try doing the same thing with plain water. In a sense this is the reverse of the first exercise.

exploring the possibilities of brushwork

The previous exercises have shown how brushstrokes are affected by surfaces of varying degrees of dampness. Nothing is visually stronger than a dark wet brushstroke painted upon a dry white ground. The fright caused by this seemingly cast-iron mark usually produces an immediate watering-down in the tone of the paint. This is the beginner's way of reducing the impact, but the experience gained from the exercises above will have shown there are others. There is a mis-conceived notion amongst beginners that the principles of watercolour automatically rule out the conscious use of line. Pen-line with wash has already been covered, but to ignore the possibilities of the use of a brushline with full watercolour is to rule out an important means of definition and drawing within the medium itself (page 44 45). To discover the potential of lines or marks made with a brush, experiment as follows, using the same colour for purposes of comparison:

different methods of holding a brush with different pressures and with different kinds of stroke—spiral, curved, straight. Dry-brush work can resemble the granulated effect of pastel (106a).

varying the size of the brush—beginners tend to use the same small-sized one right the way through a painting.

varying the consistency of the paint in the three categories already described. As skyscapes may have developed out of the first set of 'wet into wet' painting exercises, so oriental grasses may now evolve out of a contrast of bent and straight brushstrokes with stippled seed-heads. The early

nineteenth-century watercolour of a cock on page 49 uses a variety of brushstrokes to describe the different textures of the subject. Claude's watercolour, frontispiece, is superbly free and displays the control of shapes using varying degrees of wet washes. Compare the well-meant Victorian watercolour (108) with these two paintings.

acrylic-polymer techniques

equipment

atomiser-spray for use with water to prevent the painting and palette drying up, especially in the sun or in centrally heated rooms

nylon brushes for choice (softer bristles suit paint texture better)

palette preferably formica (scrapes clean more easily)

jar of water in which to stand brushes, points downwards to avoid hardening when not in use

water-pot and rag

matt and gloss mediums varnishes, gels and solvents

paints (see colour list on page 96).

Oil-painting techniques common to the acrylic-polymer medium have already been mentioned. Just as turps, not oil, is used in the early stages of an oil-painting, so water, not the medium, should be used in the early stages of acrylic-polymer painting. The 'fat over lean' principles, page 59, also apply with the use of a mixture of water and medium in the middle stages, and of the medium by itself in top coats, if the paint requires thinning. Even if a very matt surface is ultimately desired, it is unwise to avoid altogether the use of any medium. Thick impasto or relief effects are safer with the use of acrylic-polymer gel, and, if wished, can be glazed with a tinted coat of the medium. Unlike oil, it is safe to apply paint on top of such glazed surfaces. Although acrylic-polymer paint cannot be mixed with oil and oil paint, when dry it can be over-painted with them. Acrylic-polymer pigment used in a pure water-colour manner is not advisable. Watercolour effects can be achieved to some extent by going over fresh paint immediately with clean water. Acrylic-polymer pigments do not generally equal the brilliant quality of watercolour. A technique, similar to that of *buon fresco*—working into the plaster ground while it is still wet—can be used similarly with wet acrylic-polymer priming; this is the reverse of 'hard-edge' tech-niques and 'trompe l'oeil' effects, which require a rock-hard series of utterly smooth white primings. It is unwise in hot weather to try direct *alla prima* painting out of doors on anything larger than 16 × 12 ins. The fast-drying properties of the medium make it impossible.

oil-painting techniques

Those so far described have been traditional monochrome underpainting, direct or *alla prima*, and the four-stage method usually practised by most painters. They have not included detailed descriptions of some of the surface textures that are possible.

Glazing and its dangers were explained on page 54. In the reduced scale of colour reproduction justice cannot be done to this technique, but some idea of it is given on page 108, where not only the subtle flesh tints on the cheek but also the luminous shadow over the further part of the face have been achieved with this method.

Scumbling is the remaining traditional technique besides those already mentioned earlier in this chapter; dependent on an impasto surface, it is common to oil and acrylic-polymer mediums. In essence it means textural effects of broken colour. It is usually achieved by applying thin opaque paint over a passage of underpainting. It is usually stippled, dragged or rubbed on to the under-surface and contrasts with the more uniform effect of a coloured glaze. The ideal surface for scumbling is a thick, slightly irregular paint-surface which has been allowed to dry. Turner used it freely in the light areas of 'Two Women and a Letter', 44. *Relief effects* with and without the use of patent gels—page 118.

The standard oil-painter's practice is to keep the 'darks' thin and transparent, reserving the strongest lights and darks—the 'plums'—for the end; this is a sound insurance policy.

pastel techniques

Pure pastels have almost the same pigment range as oil-paints with one or two exceptions such as cobalt violet, where the ingredients, being poisonous, would make the fine dust of pastel dangerous. It is essential to regard work in pastel not as drawing but as a form of painting which, in reality, it is. It should be carried out honestly without looking unduly for effect. The general rules apply, particularly those advocating working with large areas as against small, timid strokes. The mechanically smooth, slick look of overblended pastel is an ever-present danger. The texture of Dégas' work in pastel (97) displays a considered balance between two outstanding qualities of the medium—softly blended areas of colour and fresh vigorous drawing.

oil-pastel is a medium which is very popular with children, and most of the boxes contain a colour range chosen with them in mind. At first sight it may seem somewhat violent for such subjects as landscape or still-life. If one's sense of colour has got into a rut of muted tones this may not be a liability—a dose of strong simple colour may prove very

therapeutic. One way of coming to terms with it is to make a colour-study along pointillist lines, a colour approach which relies upon optical colour-mixing rather than the mixing of pigments on the palette, page 101. The most noteworthy property of oil-pastels is the possibility of working several layers, one upon the other, blending strong colours into subtle modulations, and at the same time achieving an impasto effect not unlike oil-paint. Some brands lend themselves to this sort of hand-ling better than others. The danger of overloading the surface, very easily done with ordinary pastel, is unlikely to be troublesome. Should such a problem occur, it is quite easy to scrape the area down to a more acceptable surface.

Dégas' painting was carried out before the days of oil-pastel, but his colour scheme could well have been chosen especially for use with the standard colours of an oil-pastel box.

Wax-crayons have, and give, a nasty greasy quality. They are cheap and more suitable for infants.

Coloured crayons or pencils are inadvisable as it is difficult to produce any weight of tone with them.

Fixative should be sprayed lightly over finished pencil or pastel; heavy coatings may cause the whites to discolour. Fixative can be home-made from casein and ammonia with alcohol, but the bought solutions, of resin in alcohol or lacquer, are more convenient. 'Workable' fixative allows further pastel to be applied on top.

ink mediums

Liquid Indian ink, as opposed to the original Chinese or Indian ink in stick form, comes in two permanent varieties, waterproof and soluble. Indian inks are sometimes combined in mixed media techniques. Care should be taken, as they will not necessarily adhere to many kinds of paint. Coloured ink, other than black, is not officially guaranteed proof against light. Even sepia, strictly speaking, is regarded as only half permanent, and the attractive effects of blue-black fountain-pen ink are certainly fugitive. Several makers use the adjective 'permanent' to describe fountain-pen inks, not, as in the context of drawings, likely to be subjected to constant display in daylight. The luminous quality of coloured inks is extremely tempting, but drawings using such effects are suitable only for reproduction, or should be kept covered. *Felt-tip markers* come into this category. It is clear that a distinction should be made between ink intended for use in work to be displayed and that used for simple sketch-book purposes where the non-clogging advantages and convenience of fountain- and felt-tipped pens are very important.

COLOUR *The sensation of colour is caused by the response of waves of different frequency.* The colour of light is additive *three primary colours of light together add up to white light. By* colour of an object is subtractive—*the colour the eye sees an o ⌐⌐ be is determined by the colour rays that are not absorbed but reflected by the surface of that object*

PIGMENT *a coloured substance used to make paint by suspending it in a liquid*
DYE *a coloured substance dissolved in a liquid which imparts its colour by staining*

18 COLOUR: PRINCIPLES AND THEIR APPLICATION

Colour cannot exist apart from tone, although tone can exist without colour—in monochrome (109). An introduction to a chapter on theory of colour must start with a reference to tone. Any colour that has white added to it becomes lighter in tone, any colour which has black added to it becomes darker in tone and these variations are known technically as 'tints'. The term 'shade' is used when another colour or colours have been added. It is very good practice to paint out a similar scale of tints for two fairly equally toned colours such as light red and cobalt blue. Mixing the various gradations will prove more taxing than you expect.
A full range of colour pigments is a tool of technique:
for local colour or colour modulation
for tonal difference—light cadmium yellow versus raw sienna
for individual properties other than hue—dull and intense colour such as yellow ochre and raw sienna respectively
by omitting one colour altogether—in Lady Hamilton's cap on page 108, a steely grey has been made to appear green by surrounding it with warmer tones and contrasting it with a similar area of red
by emphasising a particular colour—the grey-green coloured ground in Derain's painting (page 104) produces a sensation of close-toned hot stillness, utterly different from the feeling of space, equally still, painted on a light ground by Cotman (page 102).
Colour can be made to work in its own right apart from its more obvious descriptive powers, but knowledge of the spectrum is needed.
Practical experience of colour mixing can be gained in preparing the charts shown on page 97. The colour spectrum or colour wheel provides a visible way of understanding the most important principles.
Information about colour and a diagram of the spectrum appears on page 112. Study this carefully.
Complementary colours lie directly opposite each other in the spectrum.

It is possible to describe the colour-scheme of this work in words because the ideas on colour at this time were symbolic or literal. Red, the colour of activity, and yellow, denoting wisdom or light, are used for John the Baptist's clothing.
The blue of water and sky and the green of the grass are traditionally regarded as passive colours.
The black and white version of Cézanne's still-life (49) compared with the colour reproduction (88) gives some idea of the equation of tone and colour.

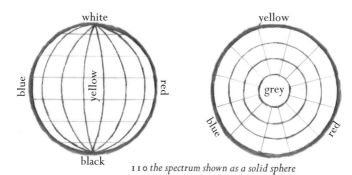

110 *the spectrum shown as a solid sphere*

Complementary colours have a very noticeable relationship which is individual to each pair. Try to be aware of such factors in a colour scheme.

Red and green are similar in tone so that, at a distance, the difference in hue is not noticeable. The commonest form of colour-blindness is that which cannot distinguish between red and green.

Orange and blue, more contrasted in tone, have an even stronger warm/cold contrast.

Yellow and purple, the most strongly contrasted in tone, have a contrast of hue which may prove unduly attractive and, if used unwisely, reminiscent of chocolate-box illustrations.

At this point it is important to refer back to the colour charts and to note that, though theoretically red and blue make purple, in practice it matters which red is used. Alizarin crimson is necessary to make a satisfactory purple. If the spectrum is studied, it is interesting to see that it lies in between the primary red and the secondary purple. The fact that cadmium red mixed with blue produces brown, not purple, underlines how important it is to study the behaviour of individual pigments in practice as well as theory.

Roughly the same situation occurs with the green, theoretically the result of mixing varying quantities of yellow and blue. To achieve the turquoise lying next door to the secondary green, it is necessary to add white to the yellow and blue mixture or preferably to use cerulean blue, a completely different pigment. It is also interesting to note that the yellow customarily regarded as primary, mid-cadmium yellow, has considerably more warmth to it than the unmixable, fundamental cadmium yellow light.

The spectrum is shown as a circle; it may also be thought of as the cross-section of a sphere with black and white at the poles (in fig. 110 above). In the very centre of this sphere, the mixture of all the colours blended together produces grey—easily proved when cleaning up the pigments

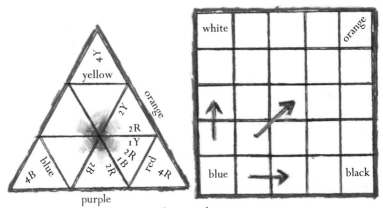

111a *three primaries converge towards grey in the centre*
111b *three directions for changing a primary: overlap watercolour washes, reducing area*
of blue by a horizontal row of squares and of orange by a vertical row each time

on a palette. Therefore, as each colour on the outer edge of the sphere
gets nearer the centre, it becomes greyer, i.e. less intense in colour,
although it stays approximately the same tone. In other words, to
reduce the brilliance of a colour, to mute that colour without altering
its tone, you should add some of its complementary colour, that is the
colour that lies opposite to it in the spectrum; e.g. to make blue greyer,
add orange. It is an exciting thing to do. Greys mixed on this principle
have a much greater range and subtlety.

There are innumerable shades, blending all three primaries in varying
proportions. The triangular diagram (111a) attempts to score up the
combinations giving red and orange and purple. If this diagram is
enlarged and carefully coloured, it will be seen how the original ingredients
become 'neutralized' towards grey in the process of being mixed.

Thus it is possible to modulate a colour in three main directions (fig. 111b):
by moving it towards white; by moving it towards black;
by moving it towards its complementary, towards grey.

Fill in with colour the diagrams above—exercises in gradation that are
exacting and revealing; remember that the diagonal movement from
blue to orange should involve progressively both a slight lightening of
tone and an increase in warmth. The movements of yellow towards
purple, and of red towards green involve different changes in tone and
warmth determined by their individual characteristics.

There are seven kinds of colour contrast; the first three have already
been mentioned with reference to pigments:

contrast of hue—any area in Seurat's painting (91)
light/dark contrast tone—Dérain's treatment of the sea (94)

cold/warm contrast—this is never referred to as temperature—Gauguin's blending of orange and green in the skin tones (96)

complementary contrast—Cézanne's warm shadows on cool green objects (88)

simultaneous contrast—the seemingly 'green' grey in Romney's portrait (98)

contrast of saturation—Mark Rothko (100), intense red with dull brown/blue

contrast of extension—balance of widely differing quantities of colour demonstrated by Mondrian (101)

The last three tend to be of largely academic interest though they help one to understand much of the thinking and research that has inspired abstract painting in this century (see Bibliography, *The Art of Colour*).

balancing a colour-scheme

When working out a colour scheme, it is helpful to analyse it particularly in terms of contrast of hue. Light/dark contrasts may disguise the fact that the colours have been drawn entirely from one side of the spectrum. A favourite colour-scheme with the manufacturers of pictorial calendars is 'autumn tints'. It consists of primrose yellow, orange, tan and mahogany-brown with a 'grass-green' mistakenly thought to give contrast. The whole colour-scheme is warm and has little contrast of hue; it depends monotonously on contrast of tone.

Colour is more exciting than this. In the case of Dérain's painting the use of blues instead of browns introduces a stronger contrast of hue, as well as a strong warm/cold contrast entirely lacking in the autumn tints range. One colour added from the opposite side of the spectrum is comparable to seasoning in a sauce, or an isolated discord in music. Contrast of hue is essential to schemes in light or dark keys (see Glossary).

limited colour

Sometimes the use of a limited palette, i.e. number of pigments, proves stimulating in one's search of colour. Raw umber and Prussian blue or ultramarine have always been a traditional recipe for this purpose, and this warm/cold contrast is the basis for Cotman's 'Yarmouth River'. Yellow ochre, cerulean blue and alizarin crimson offer strong contrasts of hue while avoiding the use of primaries. Yellow ochre, Prussian blue and raw umber act similarly, but with less violent contrasts of hue.

However, colour can be limited not only by the number of pigments used, but also by deliberately emphasizing one main colour such as brown and surrounding it with a muted range of related colours. Colours and colour mixtures that are related to each other—such as brown-tinged blues, mauves, greens, etc.—are sometimes called 'analogous', and are to be noted in Gauguin's painting (96).

112 EL GRECO St Peter *Bowes Museum, Barnard Castle*

113 GOYA etching *British Museum*

114a

114b

115a

115b

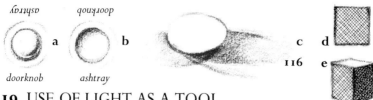

ashtray **a** *doorknob* **b** **c** **d** **116** **e**

doorknob *ashtray*

19 USE OF LIGHT AS A TOOL

Light falling on an object produces shadow; the object is revealed or 'drawn' by the light, and the shadow is the result of this. The normal method for an artist is to work the opposite way round: to depict light by drawing this shadow, as Goya has done (113). The position of a shadow indicates the light source, which is always assumed to come from above—if 116a and b are turned upside down, the effects of the shadows are reversed (see 211). It does not follow, however, that there is only one source of light. In a large room there may be more than one pendant light, so that an egg sitting on a white covered table between them will be the centre of some splendidly overlapped elliptical shadows (116c). Fernand Léger (186), a Cubist, uses two light sources in one painting.

chiaroscuro *deliberately contrasted areas of light and dark*

This is demonstrated by El Greco (112), where in a deliberately contrived arrangement it is used to produce a design in light and shade, emphasizing the message of the painting. Compare this with the Oriental practice of disregarding all effects of light (139).

reflected light

As with the rules of applied perspective, this is a device or tool which it is up to the individual to use or not, as he pleases. De Hooch, on the following page (117), nearly loses the profile of the woman's face as direct light falls upon her, so bewildering the effect of almost blinding light through the doorway, compared with the skilfully muted tones of the window; but he is careful to allow reflected light from her white apron to pick out the form of the boy's chin. Look back at the cylinder diagrams (5). Cylinders A and C look rounder than B mainly because of the darkening tone of the shadow, but also because of the reflected light as the form finally turns away from the observer. De Hooch is using observed effects of light to suit his particular subject, very different from the inspired radiance of El Greco, but just as deliberate.

Light and shadow explain form and they also indicate a change of plane (fig. 116e above). The shape of a shadow becomes another way of describing the object causing it, as with the bricks and wall opposite.

light and tonal relationships

Usually the first situation in which the student has to take a conscious decision about the use of light in a painting comes when the subject, animate or inanimate, is placed beside a window. If he makes the tone of the subject as dark as it seems against the daylight outside, without the skilful use of reflected light shown by de Hooch, he is going to be left with heavy dark silhouetted shapes, particularly disagreeable in the case of the window bars. This is the moment to question observed tone values and to make imaginative decisions. Study the detail from Tenniel's drawing (62); he has used light to solve the problem of distinguishing Alice's head from the background of window-bars in a totally arbitrary manner. Gauguin (96) is equally independent in his use of light and shade—the right shoulder of the figure casts a strong shadow across her chest; there is no such shadow on the yellow pillow beneath her other arm and hand. It would have detracted from the importance of the shape of the light-toned, yellow pillow. White or light-toned areas usually correspond to the incidence of light, particularly in monochrome works such as the Rembrandt sketch (181), where the dark shadow on the woman's face has the effect of making the white area of the lower half look bathed in light. Compare this with the Watteau drawing (9), where the white areas are used to show form first and lighting effects second.

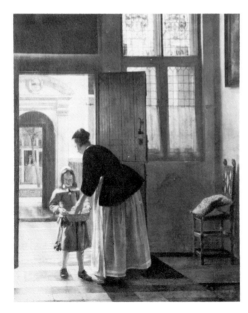

117 DE HOOCH
Boy bringing Pomegranates
Wallace Collection

tone in relation to colour

The white or light-toned areas in Gainsborough's drawing (8) indicate colour, though the white area beyond the trees also helps to give an atmospheric effect; the light areas therefore indicate lighting effects as well. Gauguin has gone one stage further and ignored the lighting effects where it suited him to do so, as with the pillow, in order to concentrate on colour. This use of colour is described as 'chromatic'.

three kinds of lighting schemes

The concentrated lighting effects of chiaroscuro and the atmospheric approach so superbly demonstrated by Turner (44) are very different from the flattened lighting effects necessary for chromatic colour first practised by Cézanne. In 88 the cool/warm colour contrast of the greys of the jug replace the traditional dark/light contrast normally used to explain form. The latter formed much of the staple diet of painters of previous centuries such as El Greco, who were little interested in the effects of local colour—it is as if he added white and black to his glorious rich colour purely in response to the need to show form, using light and shade to do so.

20 SHAPE AND FORM

form has three dimensions—length and breadth and depth—a sphere.
shape has two dimensions—length and breadth—a flat disc.
Work in three dimensions has the reality of form—sculpture.
Work in two dimensions can only create the illusion of form. This seems to imply that shape is the poor relation of form: actually it has its own particular quality, seen in the exercise with the shape of a hand overleaf, and in the little silhouetted figure (118). Fascination with shape has inspired artists from Dürer and Greek vase painters to the designers of the optical patterns known as 'Op-art' (83).

The wood-block prints used as wrapping paper round imports from Japan at the end of the last century made painters such as Dégas aware of the importance of shape—compare 119 and 97.

Their paintings show profound sensitivity to this aspect of picture-making. Previously painters had used shape intuitively, as in the cloud shapes of Cotman's 'Yarmouth River'. It is difficult to believe that this is not a twentieth-century painting.

Shape has become one of the most important ingredients of our design vocabulary, and exploration of its unlimited possibilities, to be observed by a camera as well as the eye, is one of the delights of contemporary

118

120

118a *cut-out hand showing concern for relationships between
the two sides of a finger-shape and between it and the whole hand*
118b *shape made by drawing round a hand without any concern of this kind*
118c detail of a running man, East Greek amphora 550–525 BC
British Museum

119 UTAMARO 1 coloured woodcut, end of 18th C.
crown copyright: Victoria and Albert Museum

121 WARHOL Marilyn,
silkscreen *Tate Gallery*

122 MICHELANGELO
detail,
Madonna and Child
National Gallery

art (123a, b, c). The subconscious mind reacts strongly to shape. If the top shape of 120 were cut from a thin flat substance such as stained glass, the weak neck would snap easily. With the central shape this danger would be less likely. Intuitively, therefore, it is regarded as a better shape. Bottles are so much an accepted feature of still-life that their symmetrical shapes are taken for granted, despite the immense opportunities they offer to observe two-dimensional shape in an abstract sense.

The idea of positive and negative shapes was first mentioned in the painting of the glass tumbler. Every positive shape makes a negative one, such as the gold shapes (haloes) behind the heads in Duccio's painting. This kind of awareness is immensely valuable in designing a painting and taking measurements with the eye for drawing. The significance of the shapes of shadows, shown ·in over-developed photographs, is another example of abstracted shape. Warhol's print of Marilyn Monroe is based on this technique. Compare it with the simplified and, in Michelangelo's case, unfinished shapes of the hair of the two figures on the left of his Madonna. A sense of abstract shape is complementary to a sense of form. The exercise of cutting out a hand was all that was necessary to appreciate

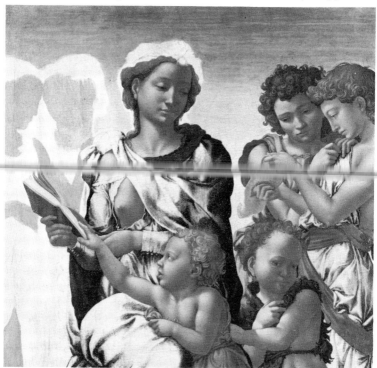

1 2 3a *chance and observation
with a camera
flat, black-and-white
2-D shapes*

sources of shape and form

1 2 3b *'objet trouvé'
sculptural qualities of
an old piece of wood*

1 2 3c *man-made forms
and shapes*

1 24 DUCCIO detail,
Virgin and Child
with four Angels
National Gallery

Raef Baldwin

shape in an elementary fashion—that is, as a two-dimensional idea (118). Perhaps all that is necessary to experience a similar sensation of form is to run one's fingers over the whole surface of one's hand, like the lines running up and over the sleeping figures in Henry Moore's drawing (134). However, it is very difficult to keep the attention focused on the essentials in the same way. The texture of the skin, the movement necessary to feel the whole of the hand besides other extraneous ideas of lighting or association—all contrive to distract attention from a simple three-dimensional concept. It is even difficult, without conscious effort or the acceptance of foreknowledge, to be sure how many fingers it has. This is often brought home when, drawing a hand slowly, adding details bit by bit, a drawing of a bunch of bananas emerges, offering little idea of the master-plan of the human original—study the different positions of the hands in Michelangelo's painting where this all-over control is clearly visible (122).

The concept of the whole for Cézanne meant a process of reduction, the elimination of particular or individual light effects and other chance circumstances, so as to simplify form and thereby explain it more clearly (88). In past centuries light has been used to indicate form by changes of plane (116e, 117). In the place of light Cézanne modulated colour to show form; this was revolutionary. Round forms were not smoothly graded but represented by planes of colour painted with rectangular

an active line on a walk, moving freely without a goal

the same line circumscribing itself

two secondary lines, moving around an imaginary line

an active line, limited in its movements by fixed points

I 2 5 diagrams from Klee's
'Pedagogical Sketch-Book'
Faber and Faber

I 26 MODIGLIANI
The Little Peasant
Tate Gallery

brush-strokes, thus making a water-jug or an apple look both faceted and round. Cézanne's art has been called the antithesis of expressive art, a turning-point of the greatest importance. One way to understand this sculptural use of colour instead of light is to make a study in a limited colour range (page 133) of an uncomplicated form such as a water-jug. Cézanne's painting demonstrates this helpfully. The warm, golden colours are used for the nearer curved surface of the jug, and cool ones for the receding sides; the tone values of these colours are remarkably similar. Lighting effects and the individual texture of the stoneware surface are not involved.

Simplification of form in this century has not necessarily meant that the influence of previous centuries has had to be ignored; in 126, evidence of Modigliani's Italian ancestry is noticeable—compare with Duccio (124).

21 LINE

 wrought iron bracket, Hereford

A line is the direct graphic expression of an artist's thought. It can therefore communicate emotion as well as direction and movement. If the artist's hand is moving firmly and thoughtfully a good line will result. If the intention is to copy or to 'go over it', without the desire to add or improve—making it a secondhand statement, even if it is of the artist's own work—the spontaneous and graphic realization of thought will not be there and the line will be dead—or slick, which is worse.

The superficial character of a line is controlled by the choice of medium and method used to create it. The character of a pen or pencil line is naturally purposeful, but the examples (129a, b) show how it can express various ideas. If the drawing material is chosen to suit the particular emotion to be expressed, the graphic results become very much more exciting. Like all illustrated artists she to be final drawing painted and engraved. Line can be as elegant as Hogarth's Line of Beauty shown on the artist's palette (203) or it can be used for functional purposes as well, see chapter heading. It can be as full of character as Paul Klee's 'line going for a walk' (125). It can set out from a point and return to that point, so enclosing an area. Then it ceases to be a line and becomes a shape. Line became transformed into shape as Picasso drew the egg-shaped white oval of the left arm (128). The line within the oval is reminiscent of Hogarth's Line of Beauty, and this curve is reflected almost unbroken in the silhouette of the nearer chair-arm and the sitter's upper arm and shoulder. The possibilities of curved and straight lines are examined further in Section 3.

ince your ambition prompts you to Excellency in the making of curious Knotts & Flourishes, I here present you with a Method for the exact performing of these belonging to Text Capitals.

1 2 7 engraved plate from 'Magnum in Parvo or the Pen's perfection'
by Edward Cocker crown copyright: Victoria and Albert Museum

1 2 8 PICASSO
Nude woman in
a Red Armchair
*Tate Gallery
this painting
has many
fundamental ideas
built into it —
see text, page 1 4 3, for
line of beauty and
ovoid themes*

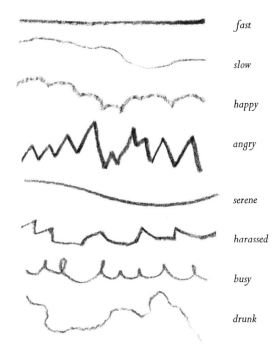

fast

slow

happy

angry

serene

harassed

busy

drunk

129a *line 'vocabulary' test*
line used to express emotions answers show versions commonly agreed

129b *line combined with choice of medium* to express the same emotions

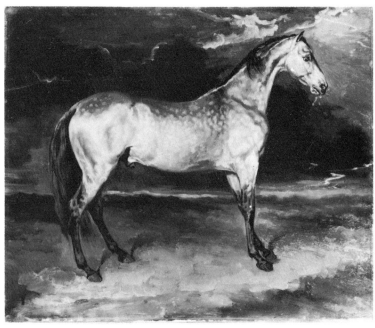

130 GERICAULT Horse frightened by Lightning *National Gallery*

131 JACKSON POLLOCK Number 23 *Tate Gallery*

22 TEXTURE: HOW TO PRODUCE IT

The word 'texture' is derived from a root meaning 'to weave'. The texture of a surface is its *more* or *less* intricate 'feel' as conveyed directly to the sense of touch or indirectly through the eye. The phrase 'to put a surface on' something can mean to make flat or textured, and focuses by its ambiguity on the fundamental division that exists in texture, the difference between two- and three-dimensional surfaces—between smooth and rough textures. Those produced by the use of particular mediums have already been described in Chapter 13, where the following general kinds of texture were also mentioned:

pattern derived from the process of manufacture weave of canvas
artificial pattern applied externally cross-hatching
haphazard texture white flecks of paper in a watercolour wash
contrived texture scumbling in oil paint

The use of all these and many hybrid combinations can be found in paintings. In addition, these techniques can be used to create the illusion of an observed texture, as in Géricault's painting opposite. What is often forgotten is the importance of large-scale textures—strings of beads or check tablecloths (99, 186); besides giving opportunities for such painters' pleasures as warm/cold contrasts and tonal passages, they have immense potential for the use of light along the traditional lines of chiaroscuro.

Techniques for texture have not been expanded in this book until now because they are as seductive an element in painting as colour. It is very easy to be carried away, and thus to lose control of the important factors in a work. Not that texture should be considered as unsuitable for a major role in a painting. It can be the vehicle by which certain statements are made about depth and the picture plane — Jackson Pollock (131). The danger lies in the ease with which texture, quite unobtrusively, can act as a saboteur in the development of an otherwise well-planned painting and wreck it. Its use must be considered as carefully as any of the other elements of picture-making. Detail of paint texture should be considered as a valid—if not always necessary—substitute for the texture of reality, and in most cases an improvement on slavish imitation.

monochrome textures

Suggested materials pencil, ink, watercolour, conté, wax-crayon, candle-grease, rubber-gum, razor-blade, sponge, textured substances (e.g. string, crumpled paper etc.)

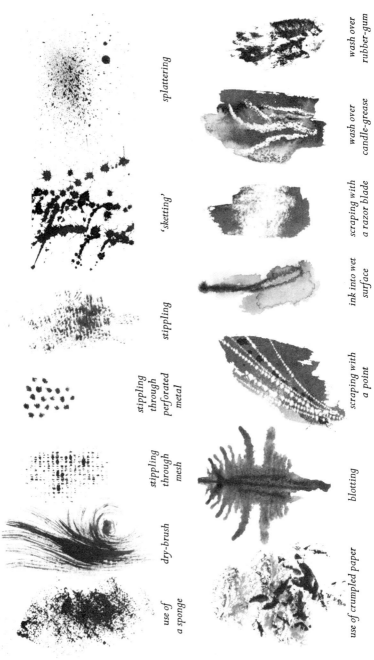

splattering

'sketting'

stippling

stippling through perforated metal

stippling through mesh

dry-brush

use of a sponge

wash over rubber-gum

wash over candle-grease

scraping with a razor blade

ink into wet surface

scraping with a point

blotting

use of crumpled paper

132 textures using waterbound mediums

The normal range of texture which can be achieved with pen and ink was discussed in Chapter 3 but, as was shown later, ink can also be diluted with water to produce a wash. Samuel Palmer sometimes added gum and varnished the finished drawing, thereby obtaining splendidly glowing effects, highly appropriate to the symbolic style and shapes of his landscapes, which were 'embroidered' with patterns or textures (133). The use of gum is rare, but it helps to overcome the difficulty of getting ink to adhere to body colour. The means must justify the end, and in this case it is a work of art far removed from the realm of ordinary black and white drawings. More spontaneous effects can be achieved with pen and wash in an unlimited number of ways, some of which are indicated opposite.

Seemingly haphazard methods, sometimes dubbed 'action painting', such as splattering the ink or paint by dragging a loaded brush against a hard edge, are controlled by masking the areas to be kept unmarked. Dribbling and blowing paint are fun, but less easily controlled. Stippling through mesh or net with a stiff, blunt brush can be useful for wire-netting. Another way of achieving a white line in the midst of an area of wash is to draw it in, before adding the wash, with the wax point of a candle for white lines, or with wax crayon for coloured lines (Henry Moore, 134); this works on the principle of grease repelling water, but it is difficult to use with accuracy and is impossible to undo if unsatis-factory. (The larger blobs of wax can be more or less blotted up through a sheet of newspaper with a warm iron, but the area affected will still be water-repellent.) Thinly spread rubber-gum, when tacky, can be rubbed up into textures with a finger; it works on a similar system. When the ink or wash is completely dry, having blotted up wet areas lying on top of the non-absorbent rubber-gum, these protected passages can be rubbed clean, leaving plain paper. Masking fluid is slightly better.

Scraping with razor blades produces a graded tonal effect, provided the paper is tough enough to take it. With the same proviso, the point of a pen-knife dragged firmly across a dark wash will produce a jerky white line useful for foreground detail. Sponging and blotting are possible, both for applying and removing washes; different pressures and con-sistencies of paint produce different textures. This can also be done with something like crumpled paper for free texture, and leads on to the idea of monoprinting (page 198).

Rather similar, but not actually the result of printing, are textures obtained by rubbing; that is laying the drawing upon a chosen surface and rubbing a soft pencil or crayon sideways across it. Broken textures,

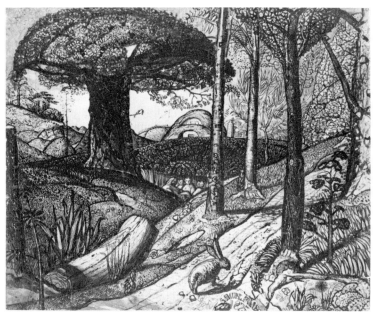

133 SAMUEL PALMER Early Morning *Ashmolean Museum Oxford*

134 HENRY MOORE part of a sketch-book page
crown copyright: Victoria and Albert Museum

larger in scale than that of conté, can be achieved from concrete or
wood.

texture in watercolour

Although carried out on the previous page in monochrome, such
textures can be used in conjunction with those stemming naturally from
the medium of watercolour, with the additional attraction of colour.
Beware, however, of 'over-icing the cake': it is advisable to use
textures very sparingly.

texture in oil-pastel

In addition to the various degrees of texture that exist between the
ordinary granulated mark of oil-pastel and the satisfyingly congealed
impasto of several layers of this medium, there is also the possibility of
thinning or spreading the pastel with turps, achieving something that
looks rather like a watercolour wash. This is best done with a swab of
cotton-wool dipped in turps before being rubbed over the pastel pig-
ment on the paper. Like all techniques, it can look 'tricksy', unless used
as a means to an end.

texture in acrylic-polymer

The difference to the spectator between this medium and oil-painting is
usually assumed to be that of non-reflecting and reflecting surfaces. In
practice, an oil-painting carried out without the use of additional oil,
and using a fair amount of turps to dilute the paint, can look very like
an acrylic-polymer painting where little emulsion medium has been
used. Both mediums can produce matt or shiny finishes without the
use of varnish, with the use of gels and mediums, acrylic polymer allowing
glazing and impasto techniques to be used with absolute freedom
(page 126). In addition, all the textural techniques of oil-painting can
be practised using water and emulsion-medium in the place of turps and
oil (see page 51).

texture in oil-paint

The various techniques for achieving this are described as follows:
Reflecting and matt surfaces, page 59; glazing, pages 54, 55; impasto
surfaces, pages 54, 118; use of painting knife for straight edges, etc.,
page 120; scumbling, page 127; addition of extraneous fillers and gels,
etc., page 118.

classic 'zig-zag' composition

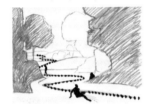

1 3 5a *dull — centred subject does not even 'bridge' the picture-plane*
1 3 5b *the two stems seem to repel each other because the lines of movement represented by the branches spring away outwards*
1 3 5c *taut relationship between the stems achieved by interaction of middle branches and proximity of two main stems*

136 NICHOLAS POUSSIN View of the Roman Campagna *National Gallery*

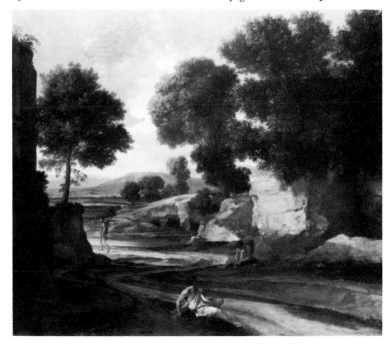

23 COMPOSITION *the role of the picture-plane*

Composition in painting becomes design when total responsibility for the planning of the subject is explored to the full by the painter, and when he goes further than just experimenting with viewpoints or the need to provide a 'lead-in' for the eye, and becomes consciously involved with the picture-plane (29b). The difference is illustrated in the Italian landscapes reproduced on the frontispiece and opposite. In Claude's Tiber view the spectator is made to feel he is looking out of a window on the world. The skyline is sensed stretching out on either side to infinity; all that is necessary to become part of this landscape is to step out of the window. This approach later became one of the primary aims of Impressionism. In Nicholas Poussin's painting of the Roman Campagna there is no such invitation. The two side-pieces or *'coulisses'* firmly enclose the zig-zag path that the painter has designed for the spectator's eye to follow (fig. opposite). There is no suggestion of a window on the world here: it is a composition carefully designed in terms of the picture-plane.

In the seventeenth century particularly, mythological and Italianate subjects were the only respectable excuses to paint landscape, and Poussin is generally regarded as the supreme exponent of this formal approach to nature, based on strict ideas of composition, that is, the planning of the structure of the picture.

Cézanne is reported to have said that he 'wanted to do Poussin again from nature'. With observation rather than imagination as the starting-point, he wanted to use nature itself to build a framework on and across the picture-plane.

working out a design on the picture-plane

It is worth trying out different arrangements of cow-parsley stems or some similar plant, on a plain white board (135a, b, c). The stems of the plant must extend at least as far as the top and bottom edges of the picture area in order to involve the total picture-plane. By moving the stems towards each other and gradually apart again, it is clear that relationships exist which can be described as spatial tensions. If these are exciting they are sufficient subject-matter in themselves and make it unnecessary to add anything else, such as a distant view, to the foreground of tautly related plant-stems. (Mondrian's painting, 101, uses spatial tensions as part of its subject-matter). In this exercise it is best to make the painting the same proportion and preferably the same size as

137 WHISTLER Old Battersea Bridge
Nocturne—blue and gold *Tate Gallery*

138a *central or balanced*
b *focal or general*
c *symmetric or asymmetric*

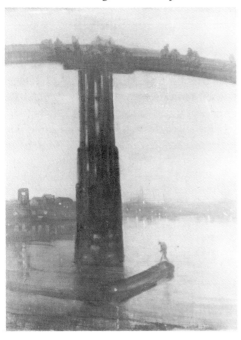

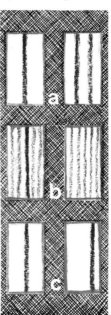

139 Sudama approaching the Golden City of Krishna, 18th C.
spatial tensions do not depend on straight lines;
the swelling forms below are just as consciously related as those
of the cow-parsley stems crown copyright: *Victoria and Albert Museum*

141 *a small rough*
has to be 'scaled up'
for transfer to
a larger picture-area;
the proportions must
be the same —
the method opposite
eliminates
the need to measure

140d *Whistler's painting reversed*

a b c

140a *looks more like a rectangle than* b *as corners are essential to the character of a rectangle;* c *needs care, not because of its asymmetry but because the stem is destroying one of these essential corners—note how Whistler has avoided this problem*

the live plants, so that tensions are preserved. Designing a painting in this way automatically assumes an awareness of negative shapes, the spaces in between things (50c).

Experiments should be carried out on the following design themes (138): central or balanced; focal or general; symmetric or asymmetric.

In the context of the last, it is useful to remember the Western habit of looking subconsciously at a picture in the same way as at a book, that is from left to right (cf. the Chinese, whose reading eye moves downwards). A painting based on an asymmetric design will look most awkward if seen reversed, i.e. reflected in a mirror (140d, the smaller version of Whistler's painting). This is particularly so if it relies on the Romantic painters' ideas on the importance of the human figure, on the assumption that the interest it arouses will allow it to balance a large mass.

There are two useful techniques when, as is usually the case, designing a picture in 'real' terms is out of the question. Lay a sheet of glass or acetate in front of the painting; prevent the glass from touching the wet surface of the painting by propping it up at the corners on blocks, possibly made out of kneaded rubber. If the surface of the glass has been well cleaned with detergent, it is possible to paint on top of it and to try out major changes.

Trial areas of coloured paper, cut out and laid experimentally on the picture can also help.

141

24 MOTIVE: WHY PAINT?

The views expressed in this chapter must, of necessity, be personal; based on teaching experience, they are put forward to help the part-time student cope with some of the problems that may lie in his way.

starting-points

To start painting a subject without any particular desire to do so is usually a mistake. The desire to paint should stem from a subconscious or conscious urge to communicate or explore something which can only be done in terms of painting, and it is useful to sketch or jot down a note or two at the start to fix this intention firmly in the mind and on paper. If it could as well be described in words or photographed, it might be better that it should. If it is a literary concept, illustration can complement or expand it in visual terms which do not necessarily have to be realistic. Bad illustration reflects the popular and usually superficial tastes of the day. Good illustration, such as that of Daumier (page 94), like good painting, extends the spectator's understanding of the subject. However, a painter may for one reason or another find himself facing a canvas with no strong visual idea in mind, but with the simple desire to enjoy mixing and applying paint to it. The reason for starting in this case is provided by the actual process of painting, and might well be described as 'research'—the artist's personal need to discover what happens in certain graphic circumstances. Perhaps he wants to try out the sort of simultaneous contrast noticed in Romney's portrait (98) or the saturation of colour demonstrated by Rothko (100). The concept, whether in terms of realism or abstraction, will form itself gradually in the painter's mind. (Conscious pursuit of an optical theory produced Pointillism.) By honest experiment the work becomes the direct embodiment of or commentary upon the chosen aspect of picture-making, and it is a first-hand statement. If this experience is later used to express an idea or concept, it is contributing to the making of another first-hand statement. If on the other hand it is repeated for effect only, it becomes mechanical —it lacks the impact of discovery; and, unless forming the basis for

144 NOLDE The Sea B (1930) *Tate Gallery*

145 PAUL NASH Winter Sea *City of York Art Gallery*

further development or exploration, it is without justification. Technique in the use of a medium is secondary to concept, but concept and medium are inseparable. When a reasonable degree of proficiency in drawing and painting has been achieved, a painter often experiences a stretch in the doldrums when the production of further work, predictable in style, seems pointless. His feeling is "Why paint the view when I could photograph it?" In fact he has hit upon a good point—a camera, even in the hands of an amateur, is a tool for just this purpose; it can record information to help him express his own considered reaction to or feelings towards the subject. The problem exists not in the subject but in the mind of the painter. Until there is an incentive, subjective or objective—perhaps embodied by the medium or by a response to nature, to society and its problems, or provided by fantasy or other aspects of personality (131, 93, 84, 142 respectively)—the painter's work will remain pedestrian and predictable. It may take time to find a theme which will provide this incentive but, when found, it will be worth the struggle, for it will have provided a subject of value. In the search, study different approaches to a subject, such as those shown by the paintings reproduced in this chapter.

outside influences

Painters have not always decided consciously on their line of development, though a study of their work might lead one to think so. The influence may have been a subconscious one, as Duccio's was on Modigliani (126)—possibly of inherited racial or environmental characteristics. Influences of this kind are strong. The link between the misty atmospheric range of the British climate and the soft muted effects of watercolour helps to account for the strong national tradition in this medium, with such superb exponents as Cotman and Turner. It also explains why, when travelling in other parts of the world than one's own, some time is needed to adjust to a change of colour-scheme in the environment.

Social influences and reaction to political situations can be an important source of inspiration; this is shown in the etching by Goya (113).

style

The question of style has not been introduced before because it can be interpreted as something self-conscious and superficial—the result of a desire to establish a saleable identity or trademark as a painter. Style is

often put on as easily as a novel piece of clothing, and as easily discarded. Study the development of past schools of painting in terms of style; they nearly always resulted from a particular set of circumstances—historical and social as well as personal. Cézanne pointed the way to Cubism by stressing the need to consider the two-dimensional picture-plane as a unit in order to analyse forms and their interrelationships. The result was the Cubist movement or style in painting, which, like the newly discovered techniques of photography, could amongst other things combine or superimpose several viewpoints, to express the idea or concept of the subject (186). This also allowed one form to penetrate another without losing its identity.

The painter does not try to reproduce a situation but to construct a pictorial fact—Braque

Cubism was the parent of all the subsequent abstract art of this century. In Nash's painting (145), the Cubist system of simplification is in complete accord with the fundamental and ceaseless repetition of the waves.

Artists must set down not things but emotions produced in our minds by things—Picabia

Broadly speaking these two statements can be associated with the twin attitudes of mind known as Classicism and Romanticism. Few painters can be put tidily into one compartment; the Classical and Romantic elements vary in different proportions in each artist's work.

The Classical approach is concerned with timeless elements of perfection, and approves the discipline imposed by a sense of historical perspective and an awareness of the achievements and contributions of its predecessors (99); whereas the Romantic approach, at times making great play with the careless rapture of personal emotion, is concerned with the more transient aspects of nature (130). Romantic painting at its best gets beyond the incidental to the universal, usually supposed to be the realm of Classical art. Classicism in excess suppresses individuality in a straitjacket of rules, and removes the element of human interest. Excessive Romanticism abandons discipline altogether, as demonstrated by some of the recent Action-painters. As an articulate movement, Romanticism is sometimes said to start with Géricault and his pupil, Delacroix, but it is a movement not confined to the mid-nineteenth century, but continuous in its influence up to the present day.

The contemporary whirligig of fashion, which art theory resembles so often, makes it necessary to keep an open mind whilst ensuring that one's own views on painting, whether abstract or not, are firmly rooted in first-hand observation and practice.

25 BASIC DESIGN

Knowledge of the principles of basic design is required by all the different graphic departments of fine art and industry, from painting to fabric-design. This chapter can be no more than an introduction, written with the immediate interests of the average mature student in mind. Further specialised reading is recommended in the bibliography.

Design involves more than arranging pleasing formations, it involves learning to use graphic means to express ideas — Morandi

Contemporary painting in all senses must have a genuine involvement with one or more of the possibilities of graphic art. It is superficial gimmickry, not 'modern art', to employ second-hand mannerisms in order to produce a 'Picasso'. The student makes worthwhile progress when, perhaps attracted by the classical idea of perfection, he seeks to find out what happens if, for instance, one line cuts another in half instead of in the ratio of the Golden Section ($1\,58$); or, moved by some spatial idea or a human situation, he seeks to express this theme by the fullest use of the medium and the principles of design. Then there is honest, visual impact; the only yardstick that can and should be applied when looking at painting of any era, particularly at work of this century.

Firm friendships result from acquaintance based on understanding and common interests. Some people will prefer straight lines and geometric shapes while others will be more at ease with flowing rhythms. This is as it should be, but despite individual preference it is important to appreciate the range of the whole design vocabulary.

As students progress, they become aware of a need for knowledge of the basic or abstract principles of design. The following pages attempt to provide this by means of experiments, variations of which should be carried out by the student; the importance of first-hand experience cannot be overstressed. The implications of the additional factors of colour and texture on design must not be forgotten, but as they have been discussed in section 2 they are not included in this section. The more theoretical manoeuvres of design, with the exception of the arbitrary use of perspective, have not been mentioned as being too far removed from the world of everyday experience. Many students are put off by the term 'abstract'; but it has a respectable classical origin in the Latin *abstractus* — 'taken from' — which implies reality as the starting-point, not idiosyncratic fantasy, as is often supposed. Man-made or natural forms and environmental effects, when examined from this point of view, can be the source of much inspiration (fig. 1 2 3).

146a *good* 146b *bad*

147a *bad* 147b *good*

148a *good* 148b *bad*

149a *bad* 149b *good*

150a UCCELLO
The Battle of
San Romano
National Gallery

straight lines

The importance of the placing of lines is immediately apparent in the diagram of Uccello's painting (150a and b), in Seurat's painting (91), or in any view containing telegraph poles, fencing, goalposts, ladders etc.

It is important to explore the geometric properties of straight lines, uncomplicated by external factors. When carrying out these experiments the use is recommended of standard units such as spills and matchsticks, trimmed of their heads.

146—isolated lines using up to 7 matchsticks on an 8″ × 5″ rectangle.

147—lines stretching in the same direction across a 12″ × 9″ rectangle using spills only, but of any number.

148—grouped lines using upwards of 15 matchsticks on an 8″ × 5″ rectangle.

149—ditto, but using lines of different thickness or weight and lengths, e.g. spill and matchstick widths together.

suggestions for further experiment

as above but with white lines upon a black background.

more than two weights and/or lengths of line.

strongly angled lines including lines at right-angles—introducing 'direction' (see also next page).

colour as bands or stripes (a tonal development of 147).

It will be evident that the use of too many contrasts—weight, length, direction and tone—is confusing. Simple designs are more successful.

151 *equal widths of white and black lines do not look equal*

150b *diagram of 150 above*

153 grid of a half-tone
screen (see page 197)

152

Symmetry and asymmetry are fundamentally opposite and
equally satisfactory approaches to design, depending on
the purpose. Symmetry is static; it gives no indication of
direction or movement. In essence, it consists of perfectly
balanced pattern. Asymmetry is dynamic and rhythmic;
it is the basis of most plant forms. (It is not surprising that
it is harder to arrange four flowerheads in a vase than five.)

direction implies movement

154a points moving outwards
154b points moving inwards

155 'pointillist' drawing of drapery

1 56 *a dark mark or point is a positive statement and regarded as a starting-point by the eye*

point

The relationships or spatial tensions that exist between individual points can be studied by taking groups of three, four and five dots in the traditional 'dice' positions and seeing how far apart they can be moved while still retaining their links as a group. Recommended by L. S. Lawley, this is best carried out by cutting up standard-sized pieces of 'confetti' of one tone and colour only, and **moving** them around experimentally (1 52). Odd numbers such as three and five are easy to arrange; three has the interesting possibility of using two pieces closely related, establishing a norm by which to judge the **movement** of the third. If the pieces of confetti are diamond-shaped, a sense of direction can be established without the need to vary the distances between them.

directional use of massed points
1 54a—Cluster of points moving outwards, e.g. bonfires—note the use of the left to right reading-habit
1 54b—From four starting points, in this case not the corners of the design area, a movement is established inwards, towards a 'heart' or 'bull's eye'; this is more difficult to achieve—the idea of looking inwards towards a light centre—e.g. a badminton shuttlecock—is a helpful concept; upwards not downwards seems to be the movement subconsciously expected—like the reading habit, it is hard to fight. Klimt's use of moving points in the design of Mme. Gallia's dress (201) is a good illustration.

1 55—folds of material drawn in a 'pointillist' manner with freely spaced dots made by a fat black felt-tip marker; compare with fig. 47.
1 53—the enlarged section of a photograph, reproduced by the system or screen of dots known as 'half-tone'.

suggestions for further experiment
Design a 'dice' face for a hypothetical number seven.
Using the pointillist manner of describing form (1 55), in full colour make a drawing of an orange on a white napkin, possibly adding a green apple—oil-pastels are ideal for this; the principle of complementary colours is a useful guide for shadow-colour. Do the same with a couple of creamy-coloured eggs and a brown speckled one.

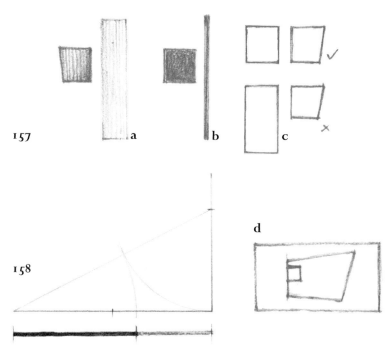

157 a b c

158 d

If various sizes of square are overlapped individually on a 2 × 3 rectangle the most satisfactory relationship or proportion is likely to be based on the Golden Section (158) discovered by the Greeks and said to control the design of the Parthenon temple in Athens (159); a possible reason for this satisfaction is the asymmetric division into two elements, to some extent combining static and dynamic symmetry. The proportion, approximately 8 : 13, is evident in such paintings as de Hooch's (117).

159

a 160 b

rectangles *of which a square is a particular example*

The technique of collage, in which shapes of paper are individually cut out and stuck down on the picture area, is recommended for these experiments; use some kind of easily spread rubber-gum so that the pieces of paper can be lifted and moved about while tacky; excess gum rubs off completely when dry. Two versions of each figure should be tried: one ruled and symmetric, and one freely cut or asymmetric.

157—quadrilaterals of varying tones, proportions and positions should be tried side by side in order to find a pair which balance each other satisfactorily. The following examples indicate the possibilities only.

a. the introduction of tone alters the situation noticeably—one dark-toned shape is balanced by a much larger mid-toned rectangle. *b.* two unequal shapes united by regularity and tone. *c.* regular and irregular version—similarity of size is helpful if two differently shaped quadrilaterals are being used. The linear quality shared by the lower pair does not appear to be enough to balance them properly. *d.* if however two such figures are contained within a rectangular shape, this last provides a unifying factor with the innermost figure, and means that the other can be freely cut or irregular.

160a—Notice in the asymmetric quadrilateral, how the subconscious urge for balance demands compensation at the top for the extreme angle at the bottom.

160b—Corners were shown in 140 to be the all-important characteristics of a rectangle. Overlapping more than two rectangles tends to destroy the characteristic corners of the figure, and produces a weak shape.

suggestions for further experiment
black or white solid figures on different coloured backgrounds
rectangles of colour as well as tone

Again it is clear that simple designs using the minimum of different kinds of contrast are the most successful. Study the work of such artists as Mondrian and Ben Nicholson (101, 169).

suggestions for further experiment

161a **b**

Imagine a view of buildings along a sea-front like a row of books on a bookshelf—if wished use photographic references, but for information only. 161a On a mid-tone ground, in collage, make a wall of buildings; 161b pattern with windows, figures, etc. in groups (use chimneys, doors, and people as the only single units) as a line drawing in black and white on overlay to be superimposed on collage.

Observe how the tone of the ground at the top and bottom of the picture-area sandwiches the design together, and how the basic design-plan of coloured rectangles is essential to give a framework for detail.

161c

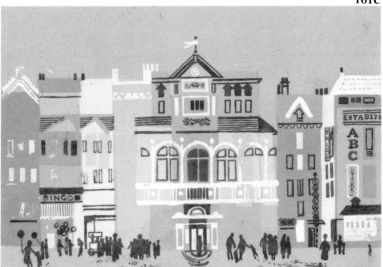

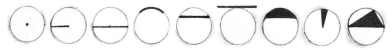

circle

A compass and a ruler should be used to draw the geometric properties of a circle. 162—from left to right: the centre and the circumference; radius; diameter; arc; chord; tangent; sector and segment. When designing or using part of a circle, these properties should be considered; as the treatment of the corners is important to the handling of a rectangle, so the properties of the circle enable the designer to hold securely an otherwise elusive and possibly awkward element. On the far right is a diagram familiar from schooldays, which demonstrates amongst other things the marriage of a right-angled triangle with a circle—two seemingly unmixable figures—but all the ingredients are contained within the list of the properties of a circle.

162 *properties of a circle*

163a *a circle in a square touching edges are tangents*
163b *this combination placed on a rectangle*
163c *note the effect*

163

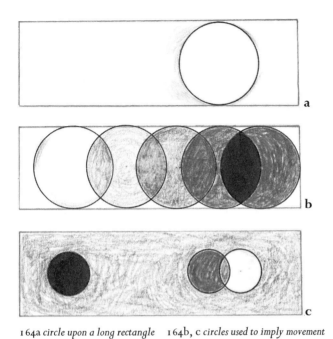

164a *circle upon a long rectangle* 164b, c *circles used to imply movement*

165 *Victorian manhole-cover*

166a *two-centred Gothic arch*
166b *four-centred Tudor arch*

167 *an egg-shape is many-centred*

165

166 a

b

167

168 *'Moonshapes' are difficult to work with (below), unlike segments (left)*

Possibly this explains why moonshapes are weaker and tend to be unsatisfactory (168). The properties of the circle are to be seen clearly in the structure of natural objects such as oranges and eggs and in the design of wheels, Gothic and Tudor arches, etc. (165, 166, 167).

suggestions for further experiment
a Make a collage based on a subject such as fruit (sections of oranges, bananas, etc.) or a bicycle or an umbrella. Collage is recommended as it focuses attention on shape and prevents the design evading this challenge, by the use of realistic detail. Designs should be planned within a given area—vignetted shapes tend to be weaker. *b* Carry out a simple geometric design based on the properties of the circle, on a larger scale, in a medium selected for the purpose—overlapping sheets of coloured cellophane or tissue-paper mounted between sheets of glass, or in perfectly painted, smooth, flat areas of colour. Experiment with the use of varnish. *extra bits do not improve an unsatisfactory design—eliminate everything unnecessary to simplify and strengthen it.*

169 BEN NICHOLSON White Relief *Tate Gallery*

173 *square* *diamonds*

a 170 b

170a *variation in position of squares resembles a 'cabin' moving up and down a 'lift-shaft' in its relationship to the vertical line*
170b *a different balance between line and rectangle made possible by the change of axis of the design area*

171 13th C. PERSIAN TILES *crown copyright: Victoria and Albert Museum*

172 *counterchange is shown here by the exchange of black and white rectangles*

| brick | half-drop | honeycomb | scale | ogee |

area division and the grid system

First thoughts tend to be in terms of the Golden Section (158), but the skilful use of other elementary principles of design—the use of circles and triangles—is to be seen in the compositions of such masters as Raphael (176). The axis or direction of a painting should be complementary to the subject: seascapes are best tried on a horizontal rectangle, and the elements of the design are planned within the picture-area with strict regard for this axis (145). The idea of movement along an axis is not dissimilar to the idea of the cabin of a lift running up and down its shaft, and has been one of the fundamental ideas in contemporary design, influencing painting as well as typography (the positioning of type upon a page), see 170 and the free or 'unjustified' edge shown on the left in caption 141.

Grid-systems, constructed from repeating units, occur naturally, as in the hexagonal honeycomb pattern; such frameworks, fusing line and area, have inspired designs of extreme subtlety and beauty (171), and lend themselves naturally to the possibilities of counterchange (172).

Counterchange stems from the positive/negative idea first mentioned on page 64, that in making one positive shape, another negative one is automatically produced, as in the ogee—or S-shaped curve—pattern (174). It is sometimes used in a most arbitrary fashion as a device to disguise structural weakness in design, and can then be most unpleasing.

suggestions for further experiment
using primary and muted or analogous colour-schemes, as well as black and white:

On squared graph-paper design repeat-patterns based on a grid-system, using accurately drawn motifs. Try for optical effects of movement through the use of direction or the appearance of three-dimensional depth—refer to the cube diagram (116e) for guidance on tone.

Working freely, design a pattern based on the repetition of roughly identical, irregular shapes, e.g. the leaf shapes on the next page.

Explore the possibilities of the grid-system in the context of circles.

174a 174b

175a geometric, curved shapes *based on a grid or repeated pattern*, cf. ribbons (176)
175b free, curved shapes *based on a repeated pattern—leaves on a branch*

176 RAPHAEL Crucifixion *National Gallery*
a geometric structure contrasted with the free, flowing lines of the angels' trailing ribbons

174a *print from string dipped in ink*
174b *similar print developed consciously*

177 *transformation of a square into a circle*

178 *standard four-centred shapes*

curved shapes and lines

Standard curved shapes are not freely drawn but based on geometry (178), whereas free curved shapes and lines are so closely related to the expression of rhythm and emotion as to be almost inseparable. The expressive movement of a free line was clearly demonstrated in 129 and, in a less obvious way, the same possibilities exist with free curved shapes. Rhythm and movement will be considered in the following pages related to emotion, as the final element in this section on design, although it is more usual to place them alongside such factors as tone, colour and texture. A standard sample from a paint-manufacturer's catalogue can display these last three factors: only a free, curved brush-mark of paint can do so in terms that incorporate rhythm and movement — expressively.

174a — *Subconscious shape:* a piece of string dipped in paint, held above the paper, and allowed to coil itself in a haphazard manner upon it.

174b — a similar print of string where unnecessary lines have been blotted out to allow a design which retains the coiling movement of the original. The free curved shapes are derived from chance arrangements, but are controlled intuitively. Another possibility is to fill in the gaps or negative shapes contained by the string with areas of paint.

177 — *conscious shape:* a square shape is trimmed in successive stages so as to produce deliberately a curved shape that is not a perfect circle; here too an instinctive sense of balance operates, as on the angles of the square (160), but in this case it is taken further, from the original figure to one that has virtually no angles. The free shape is derived from a geometric form, but controlled intuitively.

Observed shape: Nature is full of the most magnificent free curved shapes. It is foolish to ignore this source of inspiration and unwise to attempt to outdo it. The horse-chestnut leaf (183b), in reality a subtle series of shapes, is reproduced so often without thought or observation that all refinement of detail has been obliterated, and it is difficult to see it with

unbiased eyes. The remedy is to reverse this unthinking process, which is not abstraction in its recognized sense, and to go back to the original and study it. Bad curved lines and shapes are the result of lack of thought. The making of a line, whether it is enclosing a shape or not, must be an informed act, particularly when free. Straight lines go from one point to another in stages, having a beginning and an end (1 2 5), width and tone. A free line has all these, but it can also include information about speed, surface and form.

Curved shapes leave negative ones, and it is important to control the drawing or design, usually by the direct or indirect use of tone, so that the important positive shape is seen first—in the case of the chestnut leaf, from the inside to the outside. Léger (1 86) reverses this process and eliminates all form from the mug, making the curved handle a frame for the light and shade beyond.

suggestions for further experiment
Make linear drawings of different kinds of plants; simplify the drawing possibly by working on thin semi-transparent (bank) paper laid on top of the first sketch, leaving out as many lines and details as possible, making the point of the drawing the contrast between the different shapes of plant forms.

Make a study of an animal, using free continuous strokes. If necessary, rest your hand on the paper; do not remove it during the course of the drawing. Reduce the drawing to as few lines as Gaudier-Brzeska has done in his superb drawing of an eland.

1 79 GAUDIER-BRZESKA Eland *Tate Gallery*

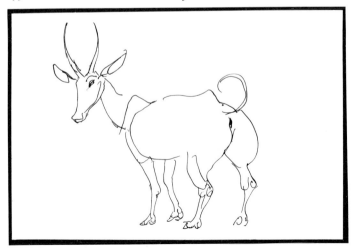

180 *egg*, a. *drawn with a pen;*
b. *cut out in paper without being drawn;*
c. *drawn freely,*
brushstroke looped back on itself

a b c

rhythm and movement—emotion

The idea of the negative form of the egg (180b) is contained within that of the positive form (180a), but a further element has been added: the flow of the hand has introduced a feeling of rhythm and movement (180c). Rhythm and movement may not be synonymous. An example of the latter could be the suggestion of motion shown by a tree—the angle of a branch (135b) as it contrasts with the upright trunk of a tree to suggest movement outwards. Rhythm involves an element of recurrence and may be either static—the pattern of buttons on a waistcoat or the beads of a bracelet (99)—or dynamic, combined with movement.

When putting a line of fencing or a row of telegraph poles into a landscape, the rhythmic possibilities of repeated pattern are important. Such a repeated pattern can be tapped out as a staccato rhythm; using the same metaphor, the looping wire between the posts could be legato. Musical analogy is not unjust: Whistler uses it in the titles of many of his paintings (page 154); as music evokes particular emotions, qualities of sound such as the muted sound of the string . . . A jerky staccato line

used to express the serene smoothness of an egg or the lines of repose in Rembrandt's drawing overleaf, would be as unsuitable as a trumpet for a lullaby. The intangible element which is emotion, strongly present for example in Nolde's expressionist painting (144) would not have been taken into account.

My charcoal drawing (182) was made in response to music. In no way does it attempt to illustrate the progression of the piece; something resembling the old-fashioned piano-roll would have resulted had this been the case. It can be highly stimulating to listen to music with some drawing materials at hand with which it is possible to work unselfconsciously, and see what happens. It is particularly interesting if contrast-

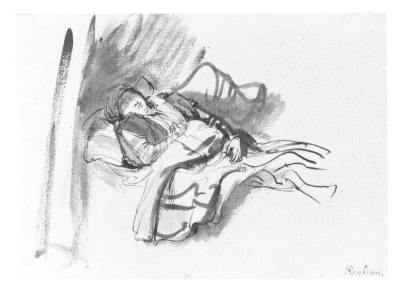

181 REMBRANDT Saskia asleep *Ashmolean Museum Oxford*

182 *Author's charcoal drawing, made while listening to music*

rhythm is often considered synonymous with growth

183a growth patterns *cabbage — rhythmic growth, enveloping a central core*
cow-parsley — staccato, in stages
lupin — radiating from the centre of a disc
silver birch — legato, flowing
sunflower — spiral movement of the seedhead

ing themes or composers are chosen—Classical or Romantic or other moods can be reflected equally in a drawing. The object is not deliberately to produce abstract work but to concentrate on expressing particular feelings or emotions unencumbered by distracting, realistic details. Avoid obviously descriptive music. If Prokofiev's 'Peter and the Wolf' or any part of Wagner's 'Ring' is played, the imagination is thick with sun-dappled or misty-blue pine-forests, and feelings of atmosphere or emotion become buried beneath the trappings of reality. One of the qualities that makes a painting great is the ability to embrace both the worlds of abstraction and realism simultaneously.

This chapter has dealt with the relevance of abstract qualities and principles to painting. It is hoped that it may also have given an indication of some of the reasons and motives that have inspired the great painters of this century, and shown why their work is not a desertion of reality but, in a new way, a development of, or focusing on, ideas that have appeared repeatedly in art since earliest times.

suggestions for further experiment
Make a drawing of rhythm and movement in the section of a cabbage, onion or flower bulb (student's drawing above, 183). Hold it in the hand for immediacy of contact, not isolated by 'picture' distance.

For contrast, make a drawing of stacked chairs or tables, or a group of trees in a landscape, to show the repeated rhythm of the uprights. Make a colour version of either or both, applying texture as well, where appropriate, without losing the concept of rhythm and movement.

183b Horse-chestnut leaves — *observation and thought are essential second-hand information produces second-rate work*

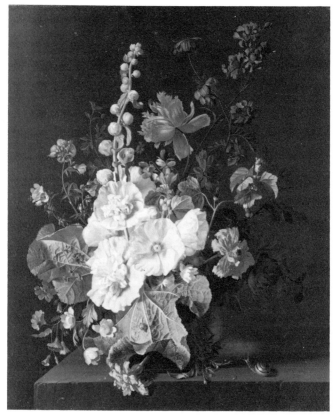

184 JAN VAN HUIJSUM Hollyhocks and other flowers in a vase *National Gallery*

26 DRAWING AND PAINTING FLOWERS

The fundamentals of flower drawing have already been covered on pages 164, 175 and on 179 under movement and growth; the importance of these to the understanding of the subject has been noted and points to the approach needed to avoid banal or superficially decorative work, as in the chestnut-leaf example. Practical points of design were made under still-life composition, page 69, in the case of long-stemmed flowers and potted plants particularly. Flowerpainting allows intense colour and readily visible rhythm and texture to be added to the possibilities of still-life; it seems to break down into three main categories.

The decorative approach of sixteenth- and seventeenth-century flower compositions was highly artificial and full of subtleties ranging from botanical history to symbolism. The background was dark and velvety to make a perfect foil for the rich waxen-looking flowers, with leaves usually veined with the texture of lace. Naïve and primitive painters also approach flowers and foliage from a decorative point of view.

A feeling for situation and light produces a very different outlook on flowerpainting, and is planned to reflect the normal human reaction to the freshness of the subject (61, 82). However, the temptation can be strong to succumb to a successful 'flower arrangement', and to record this totally different creative response—rather than to make a painting directly inspired by the subject. Even in the formal, contrived compositions of the seventeenth century, it was not the art of the flower-arranger but the painter who decided the position of the flowers.

The third approach is one of study. Its objective is accurate information, so that light and colour, usually so important, become qualities to be understated, not to distract from the purpose of the work. To this end a plain white or light background is usually chosen. It is itself is to attempt to combine this flat light background with the richness of colour and texture associated with other ways of tackling the subject, where the corroborative richness of shadow is essential.

Specific remarks on technique are out of place and unnecessary—the principles of painting, of colour, tone and form, apply here neither more nor less than to any other subject. Flowerpainting may take the form of portraiture or conversation pieces, or of surrealist or symbolic statements; but although its range of interpretation is unlimited, there is one truth to be borne in mind: a proverbial blade of grass, no matter how delicate it may seem, can push its way up through solid concrete—painting of flowers must never be feeble.

a b c

185a *Imagine a door hinged at the bottom, lying flat upon the floor — two upright, cut-out figures of identical height, also hinged, stand spaced out upon the door (185a and b). The further figure appears shorter. The door is upended, at right angles to the floor, and the hinges of the cut-out figures allow them to adjust to this new angle, so that they and the door are all standing at right angles to the floor (185c). The figures appear the same height as in fact they are.*

186 LEGER Still Life with a Tankard *Tate Gallery*

185d

187 GIACOMETTI
Seated Man
Tate Gallery

188 ORCAGNA (style of)
14th C. Adoration of
the Shepherds
National Gallery

27 BENDING THE RULES OF PERSPECTIVE

Cézanne's stated intention of 'doing Poussin again from nature' meant increasing concern with the picture-plane, and a desire to make a fundamental statement about the subjects he painted rather than one biased by the incidental effects of perspective.

For this reason he up-ended the ground-plane (185) in a manner similar to that frequently practised long before the advent of Renaissance rules of perspective (188), something that experienced grandmothers of today, proudly displaying the latest grandchild for the camera, are well aware of (185d). In the Early Italian Primitive Nativity, the crib is not completely up-ended but, as with the experienced grandmother, sufficiently so to remove the distorting foreshortening of perspective and allow a clear view of the Christ-child. This deliberate approach to perspective may be conscious as with Léger (186), or unconscious, like that of many 'primitive' or 'naïve' painters, whether of the fourteenth century or today.

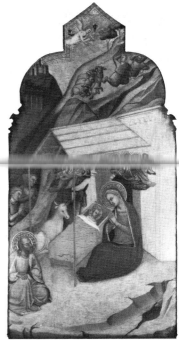

187 188

189 interpenetration—
drawing by a mature student

190 PAUL HOGARTH Connecticut Farm 1963 *collection John Holder*

191 perspective drawings of cars *Eton College pupils, age approx. 16 years*

Cubism was based on the desire to make statements increasingly funda-mental and, depending on the point of view, increasingly truthful, by exploring individual shapes and forms more fully. It led to the assump-tion of transparency. This allows one form to penetrate another without losing its individual contour, and is based on knowledge rather than sight (student's drawing opposite). Donald Anderson, to whom should be credited the concept of the 'door' (185a), makes the interesting point that Picasso's work in this direction dates from only just after Einstein's revolutionary theories: Art was in step with, if not indeed inspired by, Science. 'Interpenetration', as this use of transparency is sometimes termed, led to the further concept of simultaneous vision, where two views can be seen at the same time unfettered by the masking effects of overlap (128).

A less noticeable but nonetheless conceptual use of perspective is shown by Paul Hogarth (190). Here the essence of the subject — the textural effects of buildings and ground — would have been lost if the conventional results of perspective on scale and position had been observed. The extreme distortion of the little car (191b) produces a comic effect; car manufacturers advertise their latest 'dream-cars' by reversing this procedure.

The student's drawing in 189 gets as far as a first statement about inter-penetration. Giacometti's intention is slightly different (187) — these visual ideas are used to mark out the space surrounding the seated figure within the studio. To some extent it is as if he wishes to describe the inner surface of an imaginary mould or cast of the figure, as well as the figure itself.

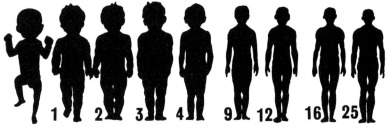

192 *varying proportions of the human head and body at different ages*

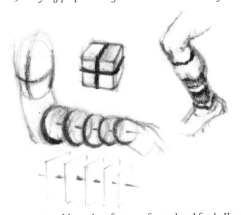

193 *sectional lines show form — of parcel and football socks; similarly of arm*

194 *weighted string or plumb-line, represented by verticals, helps to assess movement of human skeleton*

28 FIGURE DRAWING

Figure and animal subjects share many of the same problems, which can be solved in the same ways—although, in the case of animals particularly, any element of portraiture (203) may well be complicated by marking and texture. For both, rhythm and movement should be the starting points, roughed in first and, for safety, exaggerated—they are sure to become modified unintentionally during the course of the work (179). Specific anatomical knowledge can be useful, but even superficial anatomy is complex; the stylized shapes of the old-fashioned wooden lay-figure are therefore as good a method as any of visualizing the fore-shortening of a figure caused by movement. More important to the making of a 'drawing' rather than the mechanical rendering of the sub-ject, however accurate and muscular, is the relationship between movement and balance (194). Detailed anatomical information is only valid if used for this purpose, and is more relevant to the life-class. Exaggeration is nearly always necessary for some reason, and may be discerned in 98, 99 and 198 emphasizing character, form and concept respectively.

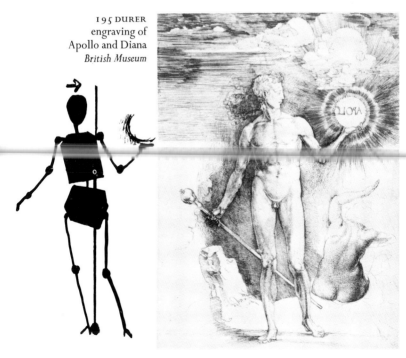

195 DURER
engraving of
Apollo and Diana
British Museum

196 PEARL FALCONER (Radio Times 1950) *displays a completely different idea of children from* 197

197 KATE GREENWAY 1879 *child appears a delectable but miniature adult from its fashion-conscious emphasis, e.g. unreasonably tiny feet* crown copyright: Victoria and Albert Museum

196

197

198 WYNDHAM LEWIS Edith Sitwell *Tate Gallery*

In 181 Rembrandt caters for awkward problems of placing by drawing the head well to the left and including the main part of the figure only. A sketch placed badly — beginners often start with the head and place it in the centre of the paper — will almost certainly not have enough room for the feet. The result is a fatal tendency to condense the length of the limbs, in order to get them all in; it is better to stop, as Dürer did in 195, and leave the drawing unfinished.

How to start a figure-study; how to control the scale:

1. mark in top and bottom of area of drawing on paper; this will be the height of the finished figure
2. from this, mark off the depth of the head in proportion — for number of heads to total height, see 40a; allow for foreshortening in the case of a seated figure (200 and 187).
3. use plumb-line to relate key points vertically such as the pit of the neck and inner ankle-bone, and so judge angles
4. take all measurements using the head as a unit
5. cross-check by comparing larger measurements, e.g. width of shoulders and knee-to-ankle

199 *figure-study, well placed*

200 *foreshortening or 'tuck' in height of a seated figure*

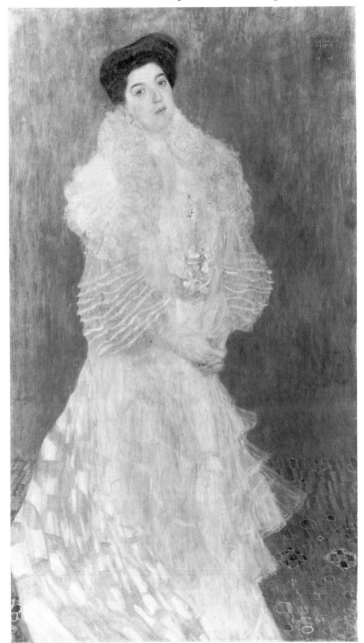

29 PORTRAITURE

Success does not depend entirely upon the sleight-of-hand known as 'catching a likeness'. Without intelligent assessment of character, this inborn ability will not lift a portrait into the realms of greatness and may even tether it to those of caricature. Accurate drawing and an awareness of what journalists sometimes label a person's 'aura'—their reticent demeanour perhaps, or extrovert appearance—are just as important. The Vorticist style of the portrait (198) suits the character of the sitter admirably, whereas Klimt's life-size painting opposite captures the elusive quality of atmosphere as well as the likeness in a totally different manner. Certainly the effect of personality can help to explain why the details of some people's features are less easy to recall than their expression, why it can prove more successful to try to portray a sitter as much by position, lighting and colour-scheme as by physical appearance.

The portrait should be designed with this in mind—whether full-length, three-quarter figure or just head and shoulders. Only then consider physical features, including such neglected ones as ears and hands, and get down to preparatory sketches, nowadays usually supplemented with photographs. (Always check the placing of features in relation to each other, i.e. the shape of the space between them, before concentrating on individual characteristics; the likeness may depend upon it.) However, there may be good reason for reversing this order of planning—if the sitter is unknown to the painter, time spent making these sketches may serve also for getting to know the sitter and deciding the nature of the portrait.

The older the subject, the easier it is for the painter. The flesh of the face has sunk into the skull and individual proportions are more clearly visible (204). Children are generally considered to be difficult subjects, not just because of their inability to sit still, but also because their faces are free of these character-revealing lines or depressions; their colouring is fresh and clear, and likely to earn the painting the adjective 'pretty'. Understatement of colour, to the extent of a move to the medium of two-colour conté, is often a remedy.

Women are usually reluctant to discard make-up when sitting for a portrait; but it can disguise or prevent the proper understanding of form (206). If strong, distinctive make-up is part of the character of the sitter, it would clearly be misleading to reduce its effect. But if it is the result of current fashion, the achievement of a less easily dated appearance is in the interests of both the sitter and the painter.

202 upward and downward curves of facial expression

203 WILLIAM HOGARTH The painter and his Pug *Tate Gallery*

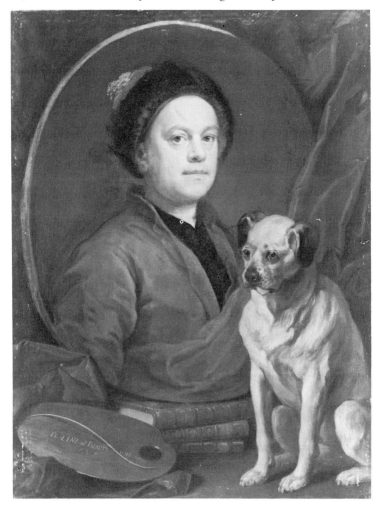

 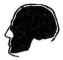

204 *effect of the skull on the form of the face*

205 *silhouette of the head is determined by the skull*

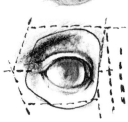

206 Apart from those of the eyelids and mouth, the movement shown by the rest of the muscles of the head is not particularly noticeable; more important are the general lines of expression (202), concave curves of happiness, convex of sadness — and the characteristics of race, age and sex (204, 205). Cosmetic advertisements are responsible for the 'tadpole' concept of the human eye; study Hogarth's self-portrait.

eye *place the eyeball in the socket of the skull and draw with the mind of a sculptor, laying the long strip of the lower lid round its base and overlapping a similar but larger one for the upper lid beneath which shadow is always centred.*

nose *establish the V-shaped planes across the eyes, construct the wedge of the nose and attach the wings of the nostrils to it; on this, individual variations can be registered.*

mouth *its form is often replaced by an area of colour — lipstick; the only definite line to a mouth lies where the three muscles of the upper lip rest upon the two of the lower lip, the latter rarely visible as separate forms.*

Eye-levels of an adult's and child's head, together with a typically unobserved version of an adult head by a beginner.

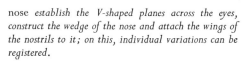

'Character' cannot be taught. Children are not taught to read 'characteristically'; but distinctly, decently, and appropriately fast. So it needs to be with writing.

It used to be assumed that respectable hand-drawn lettering was 'black-letter' or mediaeval in appearance. Tastes have mercifully changed and italic handwriting is a more legible and attractive alternative, 207 by John Dumpleton from Wilfrid Blunt and Will Carter's 'Italic Handwriting'

Venus de Milo and left, detail of hip

209

208

Eric Gill, sculptor and designer of the Perpetua type-face—lowercase 'a' 208— and David Jones, painter, poet and calligrapher (210), were friends with a common dedication to letterforms.

210

30 LETTERING, CALLIGRAPHY AND TYPOGRAPHY

208 and 209 show different designers' answers to the problem of joining a curve to an upright—the hip and waist of the Venus de Milo, and part of a lower-case or small letter 'a' of the Perpetua type-face in which this book is printed. If it is accepted that the first concern of the designer of letterform is legibility, then the next is this sculptural concern with shape. These two factors control all design, whether of cast type-faces or drawn or hand-carved lettering. The difference between type and calligraphy—between printed and hand-drawn work—is essentially the discipline of the machine, which cannot condense or expand letters or characters to suit individual circumstances; the repeated uniformity of letters provides the basis for design, as opposed to the limitless variations of the calligrapher; note the diphthongs, the combination of 'A' and 'E', in the lettering of David Jones.

Sheets of transfer characters have offered a solution for those not wishing to have type set, and for most practical purposes it is satisfactory. Like all skilled crafts, lettering offers immense satisfaction, but it is a subtle art that needs time and patience. If lettering occurs in a painting the following general points apply:

The corners of areas of lettering or type are just as important as those of any other rectangles (140). Judge the tone carefully before filling in as a solid shape. Different kinds of type, even if the same height, give different weights of tone. In a painting, once the whole area has been blocked in, the light spaces between the lines can be laid in afterwards; this 'negative' method of painting integrates it well with the paint surface.

For separated lines or words of text—termed 'display copy'—individual characters require drawing in, with particular attention to the following points:

ruled horizontal lines;

angle of uprights—for italic lettering particularly, rule parallel lines at intervals at the correct angle across the area to be lettered,

weight of thick and thin 'stresses' of each character;

large, display characters can be most decorative and, of course, care should be taken over detail; indicate specific detail such as the presence or absence of serifs throughout, but do not try to complete them perfectly; this can easily upset the balance between 'thicks' and 'thins'.

211 *detail from the Roman inscription found at Wroxeter; the top of the 'T'*
projects over the 'O' for even spacing; note the positive/negative illusion of
light and shade—in this photograph the lettering can appear either raised or
engraved according to the assumed direction of the light source.
crown copyright: Victoria and Albert Museum

If a book is lying on a table, the lettering is affected by perspective;
work out the foreshortening first before putting in the lettering.

If working out 'copy' or text to be type-set, it is essential to see that
enough space is allowed; get a specimen of the required size of type-face
from the printer.

The classic aim, ever since Roman times, has been to make the spacing
of lettering appear equal (211), even if passing fashions sometimes suggest
otherwise. The spacing of type-faces is worked out on the law of averages,
though hand-spacing for display work is not unusual.

212 GAUDIER-BRZESKA Wrestlers – lino-cut, see page 198
crown copyright: Victoria and Albert Museum

A design or drawing made specifically for printing is complete only when a print or prints have been taken. There is not one original, but as many originals as the prints made, causing editions to be limited in order to keep up the value of the print. It is important to distinguish between the original print or artist's proof, made in this way, and mechanically reproduced works where the artist did not participate in a creative sense in the printing process. In terms of graphic art these are not prints; they are reproductions, printed copies of the original work.

31 REPRODUCTION AND PRINTMAKING

A drawing is often needed for reproduction for some relatively minor purpose such as a poster or Christmas card. Some idea of the possible ways of printing the job is necessary in order to design it. If it is to be printed professionally it should be made with black ink on white paper, and, if need be, mounted on card.

It is best to work 'half-up', that is half as large again as the finished reproduction, although the same size (s/s) is usually satisfactory. All instructions to the printer, such as the exact limits of the area to be reproduced, should be made outside it or on a hinged sheet of flimsy paper, attached to protect the drawing from damage. Do not use blue or coloured ink as this does not reproduce properly.

Various office copying systems exist for duplicating information sheets, diagrams, etc. where quality is not important. They are unsuitable for artwork.

methods of reproduction

LETTERPRESS *relief system, a raised printing-surface*

line-block—most often used for reproduction in black and white; can also be used for colour work, but only within certain limits. No tonal effects are possible unless obtained on the original by penstrokes or other equally solid or dense methods of drawing. For reasons of economy, colour designs are usually for black plus one or two colour-printings—each colour requires to be printed separately from its own block. 'Colour-separations'—drawings containing all that requires to be printed in one specific colour—are usually made by the designer, who provides on each separation a key of two small crosses, placed outside the drawing on opposite sides, for the printer to check the registration, i.e. so that the various printings overlap each other correctly.

half-tone block—tonal effects reproduced by a fine screen of dots (153), suitable for reproduction of any drawing or photograph in black-and-white or colour. Colour separations, like the introduction of the screen,

are done photographically, as is any reduction in size. Full colour requires one block for each different printing as well as the necessary black one. It is expensive, but gives a good crisp quality of reproduction. It should never be described as '$\frac{1}{2}$ tone'; this means something totally different.

FLAT PRINTING-SURFACE

photolitho or photolithography—any black-and-white or coloured original reproduced by an almost invisible screen relatively cheaply, provided the 'run', or number of copies, is long enough; commercially more economical, with first-rate printing the quality can be just as good as letterpress half-tone reproduction.

silk-screen—less expensive for small runs than photolitho, it is a cruder system as it is unable to reproduce subtleties of tone.

INTAGLIO PROCESS

photogravure or rotogravure—a highly specialized method of reproduction, too expensive for 'jobbing' or everyday printing.

nb Drawings for line-block or silk-screen can be touched up with 'process-white' paint. This is not possible for half-tone or photolitho as the camera is sensitive to the slightest change of tone.

printmaking

It is interesting to learn to distinguish between the various methods of printmaking, whether or not one has the opportunity to try them for oneself.

monotypes/monoprints lie in between painting and printing; each print will vary slightly as it is the individual result of printing either from a glass or metal sheet which has been patterned in some way, or from smaller surfaces or objects printed and possibly combined with drawing and painting, to produce a graphic result.

RELIEF SURFACES *left by cutting away the block*

lino (linoleum) block (212)—quality of design must be straightforward and fresh to marry with its strong, simple technique of cutting; it will not stand up to the strain of a letterpress run: to be used commercially, a line-block copy should be made.

wood-block (119)—made from the plank or long grain of the wood; the quality of the finished print is not unlike that of a lino-block plus a strong, directional feel derived from the grain; the more permanent nature of the material gives it a longer printing life, and it is therefore suitable for letterpress jobs. Most blocks are less finely cut than this delicate example.

wood-engraving (218)—cross-grained block gives maximum freedom in use of tools; fine, delicate tonal effects can be obtained from the relief surfaces left after ingenious cutting away with a variety of tools; the engraved line is a white one—a property first exploited by Bewick.

INTAGLIO *engraved plate*
The line retains the ink when the plate is wiped clean after inking-up; the press forces the ink out to print black on dampened paper.
engraving (127)—this produces a positive black line by nature of the process, cf. the engraved white one of the wood-engraving.
etching (113)—drawn with a needle on the black wax or varnished surface of the plate, afterwards immersed in acid to bite the line into it.
aquatint—the same process with graded tonal effects made by treating the surface of the plate with rosin and heat.

FLAT PRINTING-SURFACES *plate*
lithography (84)—this method is dependent on water repelling grease; a drawing in greasy chalk or ink is made on a zinc plate or lithostone; the plain areas, after treatment, are dampened and ink is then accepted only by the greasy sections.
silk-screen (*serigraphy*) (121)—the plain areas of the design are made resistant so that printing-ink can only be forced through the positive areas or lines of the drawing.
With the exception of silk-screen, every print is a mirror image of the surface making it. Designs for all the autographic methods listed above, with this exception, must be reversed before being carried out on the printing surface—in 195 Dürer has omitted to reverse the lettering. All commercial systems of reproduction can do this at the photographic stage.
Lino-blocks and cutters are readily obtainable and easy to use; wood-engraving materials are expensive and require more skill. Both can be handprinted by burnishing the back of the paper as it lies on the block, with the back of a spoon. With skill, small lithoplates can be printed using an old-fashioned kitchen mangle.
Scraperboard is not included above because it exists only as a single original. It is not possible to print from it directly, though it can be reproduced by line-block.
The drawing is made with a needle which scratches a white line from the black-coated surface of the card; the effect at a distance, or if reproduced, can look very similar to a wood-engraving but without the richness of toolwork.

32 FRAMING AND PRESENTATION

If it is worth framing, it is worth framing properly. Apart from security and protection, framing is the final stage in a drawing or painting, and can support, contain or complement it according to need. Painters such as Klimt occasionally decorated the frame themselves to achieve unity of this kind. In this introduction one can only offer guidelines. Remember that the framing of drawings and watercolours requires at least as much thought as the framing of oil paintings and often receives less. Even protected in a portfolio, the appearance of most drawings is improved by a mount.

mounts These should be stiff—made out of white, tinted or coloured card on to which the work is 'tipped' or attached with double-backed sticky-tape, or with the merest spot of glue at the corners. A hinged mount with a cutaway window is even better, as the edges of the work are covered and it is ready for framing when required. Choose the colour with care. Light-toned mounts—white, or off-white for work not on a white ground—give a feeling of space; coloured mounts, particularly of a dark tone, can contain an otherwise sprawling composition. The shade chosen need not be analogous; it can be a good idea to pick up a colour contrast or emphasis within the painting. Linen or other materials can be used for mounting, and the use of texture instead of, or as well as, colour is an interesting possibility, though care must be taken not to swamp the subject. Make the bottom margin appreciably larger than the top. Borders can be ruled round the window of a mount in pencil (remember that this will affect the proportions) and can be filled in with wash. All drawings and watercolours require room to breathe, and this is provided by the mount. Paintings on canvas or its equivalent are usually unmounted, but can be protected by a coat of varnish—this should be thinly applied three to six months after completion. It need not be shiny. Different kinds of varnish are listed on page 119.

A less expensive alternative to framing for drawings or watercolours is to hold the work between the glass and backing board with metal clips manufactured specially for the purpose. This method is particularly suitable for contemporary subjects with an attractive edge, such as the deckling of watercolour paper. The practice, sometimes known as 'baguette', of finishing a picture by glueing strips of wood up the sides, with butted rather than mitred corners, can also be attractive.

frames Mouldings come in a bewildering variety of shapes and sizes, and there is colour too to be considered. It is normal to choose something

fairly light in tone and actual weight for drawings and watercolours. Antique or secondhand frames can sometimes be found and may decide the size and colours of a future painting. For oil paintings, mouldings with a raised face are advisable, to give a slight feeling of depth; they may vary from about one inch wide for a small painting to three inches or more for a large canvas, and are occasionally increased by a 'liner', that is an extra inner frame. If you have the skill to make your own frames you will need a mitre-box and clamps.

exhibiting

Enjoying an afternoon's painting can be enough to fulfil the creative urge, but there is another reason for wanting to draw and paint which may already have become more important to you. This is the need to communicate a visual idea.

If this happens it makes sense to complete this line of communication by exhibiting one's work, to show it to a larger public than just one's family or friends. Viewing it up on the wall, along with others, is helpful—confirming or redirecting the course to be followed in one's painting.

A sensible way to proceed is to join a local art group or club, which will qualify you to enter work for any exhibitions they may arrange, and may also provide some of the social benefits people enjoy from working together in groups. Another possibility is to enter work for competitions organised, often nationally, by manufacturers or other bodies interested in promoting painting and/or its materials. But this is a limited field in which success and failure may have little relation to merit.

The most unassuming means is to persuade your local library, restaurant, theatre or cinema to allow you to mount a small show of your work in a foyer or entrance hall. Entries to open exhibitions held by societies interested in particular mediums or genres of painting (e.g. watercolour, portrait) may follow from these beginnings. Works submitted to exhibitions must always be properly framed, and must be handed in at a specific time and place: this is one of the services offered by artists' agents.

Success in exhibiting is exciting but not an end in itself. To be the medium through which a good drawing or painting comes to life is more stimulating than the best champagne.

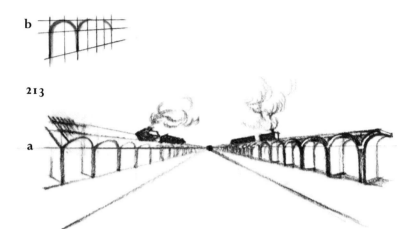

b

213

a

appendix *additional perspective information*

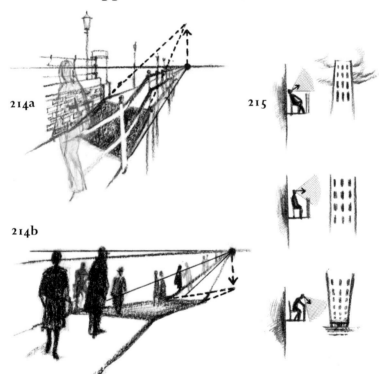

214a

214b

215

216

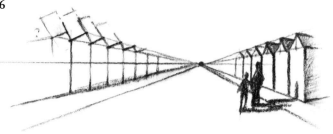

2 1 3a arches *on left of this diagram appear to lean forwards because the curve of the first half of each arch is not foreshortened correctly—if the railway-track across the top were added in relation to them, the train would be tipped off*
2 1 3b arches *decrease gradually in size: mark in the middle of each arch, making the further half slightly smaller (but larger than the nearer half of the next one) and draw in the curve—the rising curve of an arch in perspective is rounder and seemingly shorter in length than the descending curve which is flatter and seemingly longer in length*

2 1 4a rising ground-level *the vanishing point is moved directly upwards at right angles to the eye-level; when the ground becomes flat again, the vanishing point drops back into its former position on the eye-level*
2 1 4b falling ground-level *the vanishing point is moved directly downwards at right angles to the eye-level; when the ground becomes flat again, the vanishing point reverts to its original position on the eye-level*

2 1 5 differing angles of the cone of vision *affect perspective—the observer stays in the same place but tilts his head*

2 1 6 gables and circles (wheels and clocks) *the same rules of construction apply as with arches*

2 1 7 *houses on hill-slopes have horizontal floors*

reproductions

index

glossary

action-painting—*abstract (non-figurative) expressionism*
axis—*the backbone of a picture round which it is designed*
buon fresco (fresco)—*painting wet plaster with watercolour*
conceptual—*born of an idea in the mind (cf. perceptual)*
Cubism—*fusion of the conceptual element of African art with Cézanne's concept of realism*
dark key—*tone values pitched at the bottom end of the tonal scale*
deckle edge—*the rough uncut edge of handmade paper*
Expressionism—*movement in painting concerned to 'express' emotion or feeling*
field—*visible area of ground, the actual surface to be painted*
foreshorten—*to represent an object as shortened by perspective*
Impressionism—*movement concerned with the sensation of light disregarding academic rules of colour and composition*
light key—*tone values pitched at the upper end of the tonal scale*
local colour—*close variation of colours within self-colour area*
medium—*i liquid constituent of paint, liquid with which paint is diluted*
ii *mode of expression of artist e.g. painting, sculpture*
objective—*actual, uncoloured by one's emotions*
Op-art—*movement concerned with optical effects*
perceptual—*directly concerned with the senses e.g. sight (cf. conceptual)*
Pointillism—*painting based on optical mixing of points of colour rather than physical mixing of pigment*
Pop-art—*popular culture of the early 1960s, modern equivalent of folk-art*
self-colour—*basic flat colour of an area or object*
subjective—*relating to the subject i.e. one's own consciousness*
Surrealism—*movement using non-perceptual images (dreams) to evoke the mysterious, subconscious or metaphysical state*
trompe l'oeil—*simulating reality (especially in murals)*
vignette—*a drawing or painting without a rigid edge*
Vorticism—*British offshoot of the Cubist movement*

metric conversion table equivalents shown below are only approximate

1 in = 2·54 cms

C E N T I M E T R E S	
1 —— 2·5	
2 —— 5	
3 —— 7·6	
4 —— 10	
5 —— 12·7	
6 —— 15	
7 —— 18	
8 —— 20	
9 —— 23	
10 —— 25·4	
11 —— 28	
12 —— 30·5	
13 —— 33	
14 —— 35·6	
15 —— 38	
16 —— 40·6	
17 —— 43	
18 —— 45·7	
19 —— 48	
20 —— 50·8	
21 —— 53	
22 —— 55·9	
23 —— 58·4	
24 —— 61	
25 —— 63·5	
26 —— 66	
27 —— 68·6	
28 —— 71	
29 —— 73·7	
30 —— 76	
31 —— 78·7	
32 —— 81	
33 —— 83·8	
34 —— 86·4	
35 —— 88·9	
36 —— 91·4	
37 —— 94	
38 —— 96·5	
39 —— 99	
40 —— 101·6	

INCHES

ounces 1 —— 30 *grammes*
2 —— 55
4 —— 115
8 —— 225
16 —— 455

pints ¼ —— 142 *millilitres*
½ —— 284
1 —— 568
2 —— 1136

bibliography

RALPH MAYER The Artist's Handbook
Faber 3rd. ed. 1973

DONALD ANDERSON Elements of Design
Holt, Rinehart, Winston 1961

JOHANNES ITTEN The Art of Colour
Van Nostrand, Reinhold 2nd ed. 1973

E. H. GOMBRICH The Story of Art
Phaidon reprinted 1966

KENNETH CLARK Landscape into Art
John Murray 3rd ed. 1952

PETER AND LINDA MURRAY A Dictionary
of Art and Artists *Penguin Reference Books*

LEONARDO DA VINCI The Notebooks of

JACK KRAMER Human Anatomy and Figure Drawing
Van Nostrand, Reinhold 1972

DR PAUL RICHER Artistic Anatomy
Watson-Guptill 1971

LYNTON LAMB Drawing for Illustration
Oxford University Press 1962

MICHAEL ROTHENSTEIN Linocuts and woodcuts
Studio 1962

TOM GOURDIE Improve your Handwriting
Pitman 1975

NICOLETE GRAY Lettering as Drawing
Oxford University Press 1971

PRUDENCE NUTTALL Picture framing
for Beginners *Studio Vista* 1968

JOAN ABSE The Art Galleries of Britain
and Ireland *Sidgwick and Jackson* 1975